IMAGES
of America

OGDEN'S
TROLLEY DISTRICT

IMAGES
of America

OGDEN'S
TROLLEY DISTRICT

Shalae Larsen and Sue Wilkerson

ARCADIA
PUBLISHING

Published by Arcadia Publishing
Charleston, South Carolina

Printed in the United States of America

Library of Congress Control Number: 2012942203

For all general information, please contact Arcadia Publishing:
Telephone 843-853-2070
Fax 843-853-0044
E-mail sales@arcadiapublishing.com
For customer service and orders:
Toll-Free 1-888-313-2665

Visit us on the Internet at www.arcadiapublishing.com

*This book is dedicated to the visionaries who laid the tracks
and developed the neighborhood, and to the people, past
and present, who call the Trolley District home.*

CONTENTS

ACKNOWLEDGMENTS

Ogden's rich history would be lost to the world if not for the efforts of private and public collections. The Stewart Library Special Collections at Weber State University and the Union Station Photograph Library have both been invaluable resources in the completion of this book. Sarah Langsdon, curator of special collections and fellow Arcadia author, has been immensely helpful and knowledgeable, guiding us through a wealth of historical documents in search of the elusive Trolley District streetcars. Lee Witten, director of special collections at Union Station, was also invaluable in this project. For hours, Lee humored our questions and requests to rifle through the hard copies of photographs, despite the fact that much of the Union Station collection has been digitized.

We would also like to recognize the Jefferson Supper Club, our closest friends and neighbors, whose energy and passion for Ogden is contagious. Thank you to our best friends Tamara Anderson, Chip Anderson, and Travis Larsen for sharing so much time with this important cause.

This book features images from the Weber State University Stewart Library Special Collections (WSU), the Union Station Photograph Library (Union Station), and other private collections.

INTRODUCTION

When one thinks about streetcars, they probably visualize San Francisco's rolling avenues and open-air cars overlooking the bay, the bridges, and rows of painted ladies. Or perhaps they visualize New Orleans, with one of the oldest intact streetcar systems in the nation. Ogden, Utah, is also synonymous with rails—the little-known town was put on the map when it became Junction City in 1869. With the joining of the Union Pacific and Central Pacific rail lines at Promontory, Ogden became the most significant destination between San Francisco and Denver. Everyone traveling east or west across the country went through Ogden, including presidents and foreign dignitaries. Perhaps even more impressive are the regional and national leaders of industry who called Ogden home. Today, the names Eccles, Scowcroft, and Browning are just some of those gracing civic and institutional centers throughout Ogden, the state of Utah, and the nation.

Ogden's historical significance dates back before statehood. Early settlers crossing the plains would stop at the confluence of the Ogden and Weber Rivers to take a break from the harsh desert landscape. The trappers who set up camp at the junction—the "Weber County Rendezvous"—in 1825–1826 provided some of the earliest records of the area. During that fall and winter, a gathering of over 700 trappers and their families, along with over 2,500 Snake Indians, overwintered at the site that became Ogden City. According to Milton R. Hunter in *Beneath Ben Lomond's Peak: A History of Weber County, 1824–1900*, "While the canyon streams were frozen over, the trappers occupied themselves by occasional fights, trading for furs and making love to the Indian women." These early tales of Indians, trappers, and explorers fill historical novels, illustrating the challenges they faced in contrast to the often-imagined romance of the pioneer era in other works of fiction.

Ogden City was named for Peter Skene Ogden, a trapper who worked for the Hudson's Bay Company. His first visit to the site was in 1830. By 1841, the trapping industry was dissolving, but mountain men James Bridger and Miles Goodyear remained in Ogden City. Goodyear, the last of the trappers, sold much of his land to the Mormon colonizers. His cabin, which has been moved seven times, is the oldest remaining structure in Utah. Originally built in 1845 on the banks of the Weber River, Goodyear named it Fort Buenaventura, a name still in use today. The cabin now sits at Lincoln Avenue and Twenty-first Street, hopefully its final resting place. In January 1848, Capt. James Brown and his sons moved to Fort Buenaventura but were not fond of the name, renaming it Brown's Settlement and then Brownsville. Finally, Ogden City was named by Brigham Young.

The completion of the transcontinental railroad drastically changed the landscape of the western United States and altered the course of Ogden's future. On May 10, 1869, the Union Pacific and Central Pacific Railroads were officially joined at Promontory, 40 miles northwest of Ogden. After the driving of the famous "Golden Spike," life for the city of Ogden changed forever and the city soon came to be known as Junction City. The wealth of the railroad, industry, and banking, combined with its amazing scenic landscape, made Ogden a desirable place to live, and

the population quadrupled from 3,000 to over 12,000 between 1870 and 1890. All of these factors combined with the ingenuity of many local characters made Ogden City a town of legends.

In 1883, the Ogden City Railway Co. constructed and operated Ogden's first city rail line. The early trains were mule-drawn and transitioned to small steam engines by 1889. In 1891, the electric streetcar made its appearance on Ogden's streets.

As the new Junction City boomed, so did the neighborhood directly east of downtown, with merchants and businessmen building fine homes on the first bench above the bustling city. The popular downtown streetcar system was expanded to provide ease of access between the commercial core and first bench neighborhood, conveying citizens from home to work, dining, and shopping. The trolley system grew, and streetcars were built nearly every two blocks, including east-west routes along Twenty-first, Twenty-third, Twenty-fifth, and Twenty-seventh streets.

Much of the system was developed under the direction of the Ogden Rapid Transit Co., with Edmund G. Vaughn as the executive vice president. In 1900, David Eccles, Thomas Dee, & Associates changed the name to the Ogden & Northwestern Railway. After several mergers and another split, the Utah Rapid Transit Company emerged in 1920 and operated the Ogden City streetcar system until December 26, 1935, when the company officially discontinued trolley service as public transportation transitioned to buses. When the streetcars stopped running, some of the trolley tracks were removed and others were paved over, only to be rediscovered nearly a century later.

Ogden continued to enjoy prosperity and prominence through the 1950s but fell victim to the post–World War II flight and decay of urban centers across the nation. In this era of "urban renewal," many of the nation's historic places were razed to make room for public improvement projects. During that era, Ogden lost many of the places featured in this book. Still, an amazing number of buildings survived the modernization of the city and are still standing today—a testament to the cultural value and meaning they have to the citizens of Ogden.

Today, the central city is undergoing a renaissance. People of all ages and backgrounds are realizing the convenience the Trolley District offers, with its walkable downtown, rich history, and bright future. Ogden began to capitalize on its incredible outdoor resources in 2002, when numerous outdoor recreation companies were recruited in a successful effort to make Ogden the "outdoor recreation capital of the world."

In addition to the newfound energy of downtown Ogden, the streets of the Trolley District are starting to come alive. Many individuals and families are rediscovering the amazing past and beautiful architecture of this place. Hundreds of homes are currently undergoing restoration and a sense of community is flourishing as neighbors share stories of their home's past and future at block parties. This transformation has been facilitated by the city's own neighborhood development organization, which continues to renovate historic homes and restore mansions that have been cut up into apartments back into single family homes. There is now hope that someday streetcars might once again roll through the neighborhood and reconnect the community.

One

CROSSROADS OF THE WEST

The transcontinental railroad changed everything for Ogden and the United States. A Union Pacific engine left Ogden on March 8, 1869, taking with it the tales of old Ogden, filled with trapper tents, pioneer tradesmen, failing wooden bridges, and Indians. The engine followed the tracklayers and headed for the meeting place "somewhere west of Ogden"—a sleepy stretch of open prairie called Promontory. The new community of Ogden was ablaze with the string of commerce and excitement that the railroad brought.

This rare gift of economic stimulus might never have happened if the Utah legislature had gotten its way. In 1854, when the plans for the intercontinental railroad had the nation alive with excitement, the state legislature attempted to alter the route of the rails down Provo canyon and around the north end of Utah Lake. Fortunately for Ogden, the railroad engineers preferred the Weber Canyon path, deeming it a superior grade for rail. In April 1869, congress proclaimed Promontory to be the exact meeting spot for the east-west junction and Ogden, being the closest town, was dubbed Junction City.

After the meeting of the east-west rails at Promontory, a boom hit the new Junction City that was sustained for nearly a century. The rails brought wealth and prominence to the former pioneer settlement and spurred exponential growth in population into the late 1890s. The once isolated Mormon colony was immediately confronted with an influx of non-Mormons, or "gentiles." The railroad also brought a host of socially frowned-upon behaviors like drinking, gambling, and prostitution. Ogden quickly became a more tolerant city compared to Salt Lake City, where tensions ran high for generations. Even today, Ogden reflects a tolerance and diversity that make it unique.

Ogden has also been known as the "Crossroads of the West," boasting intersections of east, west, north, and south rails, and eventually roads. The advent of the iron horse brought an eclectic mix of travelers through Ogden and the stage was set for an amazing future, which has subsequently unfolded. The Crossroads of the West eventually gave rise to the Trolley District, housing the people who chose to settle in the new railroad hub.

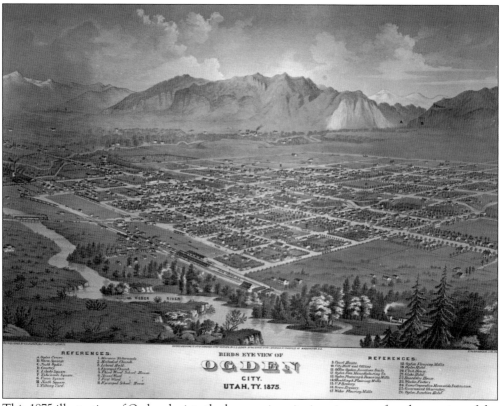

BIRDS EYE VIEW OF
OGDEN
CITY.
UTAH, TY. 1875.

This 1875 illustration of Ogden depicts the burgeoning city just six years after the coming of the railroad. Growing eastward from the Union Pacific Station, the city exemplifies transit-oriented development. The image highlights the railroad's influence as the source of growth and center of activity in the new area. (Courtesy of Union Station.)

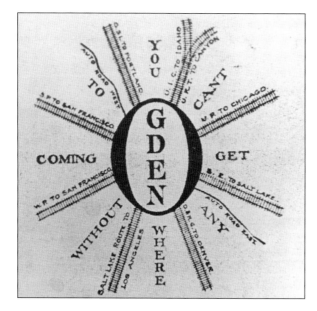

The earliest known Ogden Chamber of Commerce logo is iconic for its representation of the city's central location and junction-city status. It highlights all of the routes and the rail companies along those routes. Note that the line to Salt Lake City is labeled "B.R.," quite possibly the Bamberger Railway, and the line to "Canyon" is "U.R.T.," perhaps the Utah Rapid Transit company. Several other railroads are featured, including Denver & Rio Grande, Union Pacific, Western Pacific, Southern Pacific, Oregon Short Line, and Utah Idaho Central. (Courtesy of WSU.)

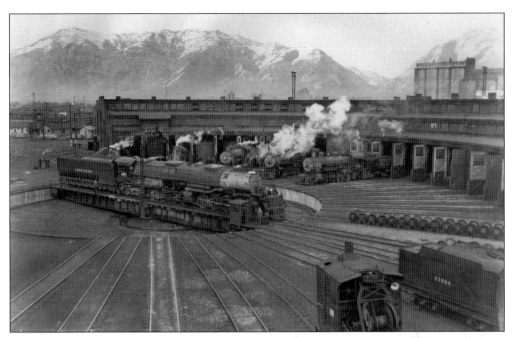

Following the joining of the Union and Central Pacific Railroad lines at Promontory on May 10, 1869, Ogden became a national center of modern transportation. The Union Pacific roundhouse was built to service the massive locomotive engines powering the cross-country fleet. This semi-circular building was centered around an enormous turntable, which rotated the large locomotive engines for storage and service in the bays of the roundhouse. The above image from around 1945 shows the Union Pacific Steam Locomotive No. 4017S1MP, Big Boy class designation, on the turntable. Below, local engineers pose on a Union Pacific steam locomotive while they prepare the engine for trips to points beyond. (Above, courtesy of Union Station; below, courtesy of WSU.)

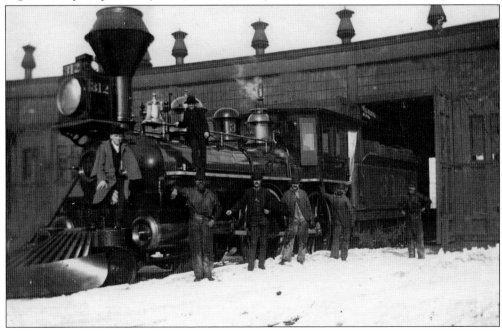

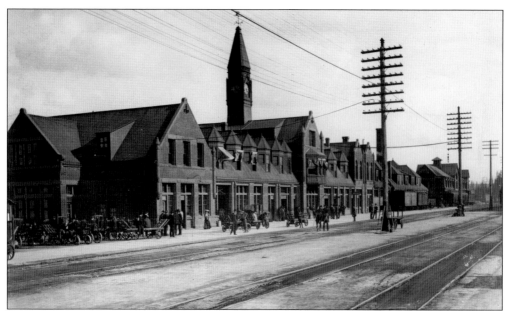

The railroad platforms were rich with culture, wealth, and diversity, still hallmarks of Ogden's societal landscape. The Ogden City Commission's 1940 work *Ogden History* described it thusly: "At train time, it was an interesting sight to watch the makeup of railroad passengers, amongst whom one would see blue-coated, brass-buttoned officers and soldiers of the United States Army; mining men; prospectors; longhaired buckskin-dressed mountaineers and trappers; red blanketed Indians from the Indian country north, west and south; Chinamen of the old primitive time wearing the bamboo, top-like hat. Added to these were well-dressed, well-to-do travelers from the eastern cities going to California and quite aristocratic-looking English, French, Dutch, and Germans traveling by way of San Francisco and the Pacific to China, Japan, New Zealand, or Australia." The original Union Depot was built in 1889 and destroyed by fire in 1923. (Courtesy of WSU.)

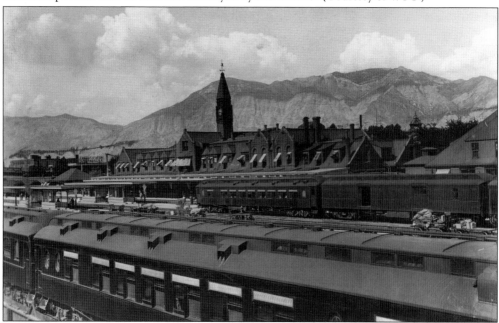

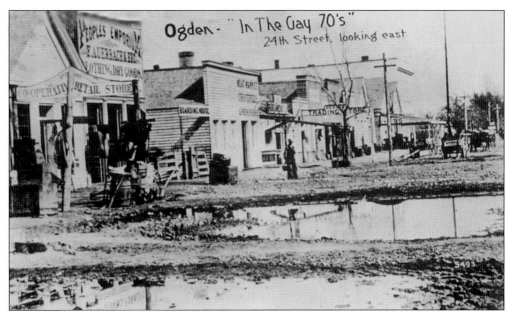

In the 1870s, Ogden's streets were still those of a makeshift pioneer settlement. This view looking east from Twenty-fifth and Washington Streets shows how particularly problematic the dirt roads were. When it rained, the roads were so caked with mud they were impassible. (Courtesy of Union Station.)

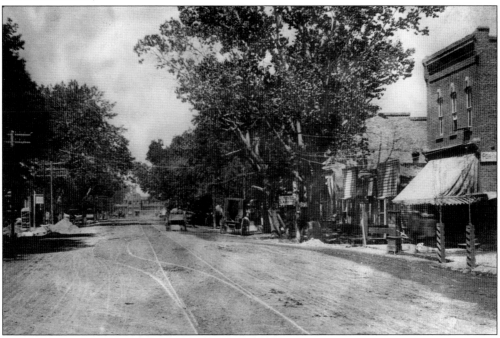

From the dirt streets of downtown Ogden arose an opportunity to create a system of transportation to bring the city into the 20th century. This photograph looking west on Twenty-fifth Street from Grant Avenue was taken at the beginning of the trolley era in the mid-1880s. While there are tracks in the ground, the scale and character of the dirt street is still that of a wild western town. (Courtesy of Union Station.)

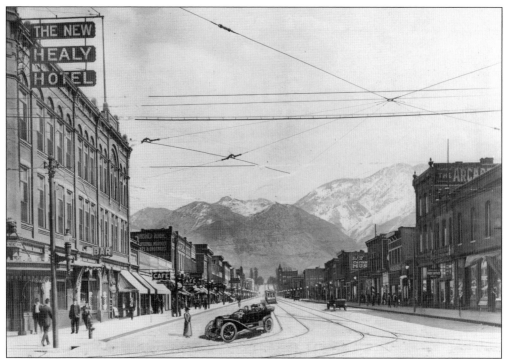

Twenty-fifth Street is perhaps the most photographed place in Ogden and the streetcar was a constant element for a half-century, guiding the steady evolution of the city. The above image has been augmented with a hand-drawn overlay visually emphasizing the automobile and the streetcar, mixing real people and drawn-in images. Below, the business bustle of the early 1930s is seen in the central business district. (Courtesy of WSU.)

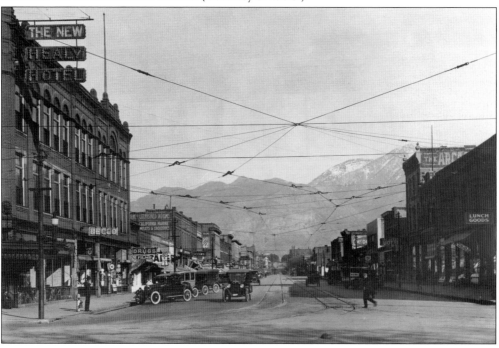

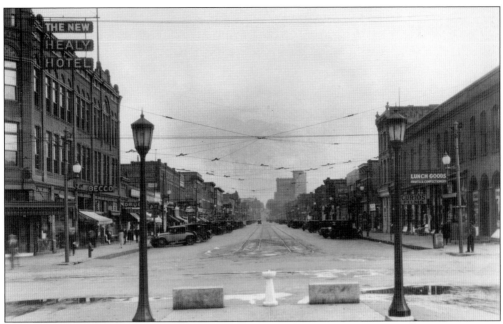

Extending eastward from Union Depot, the infamous Twenty-fifth Street was the front door to Ogden and the red carpet of the railroad. Its businesses catered to the needs of cross-country travelers and boomed with the inundation of rail traffic in Ogden. Above, looking up Twenty-fifth Street from Union Station, the maze of catenary wires illustrates the extent of streetcar operations at the end of the 19th century and shows many buildings still standing today. The below image, taken from a similar location, shows Mount Ogden and Taylor Canyon overlooking bustling Twenty-fifth Street. The streetcar is on its way out, as seen by the absence of the overhead catenary lines. (Courtesy of WSU.)

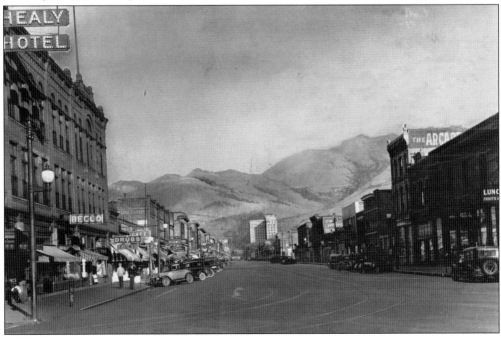

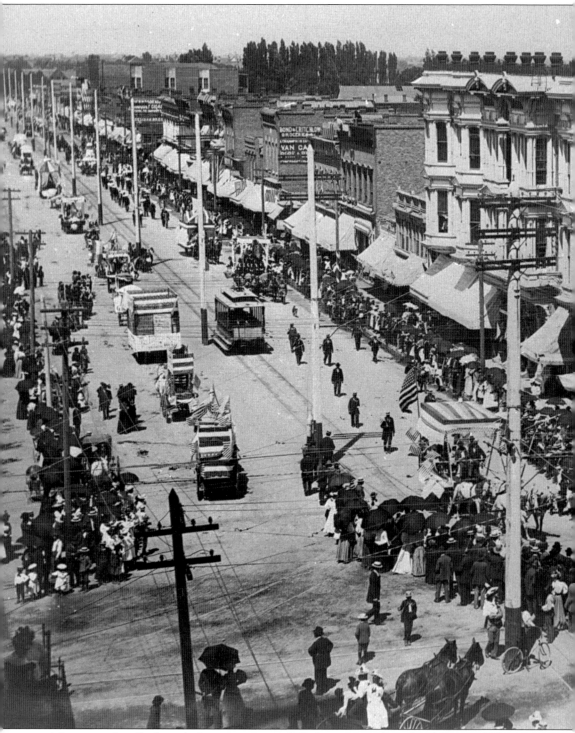

A large parade rolls through the intersection of Washington Boulevard and Twenty-fifth Street, directly in front of the famous Broom Hotel. Surprisingly, the festivities appear to commingle with streetcar operations. The elaborate Broom Hotel was built in 1883 by John Broom, providing

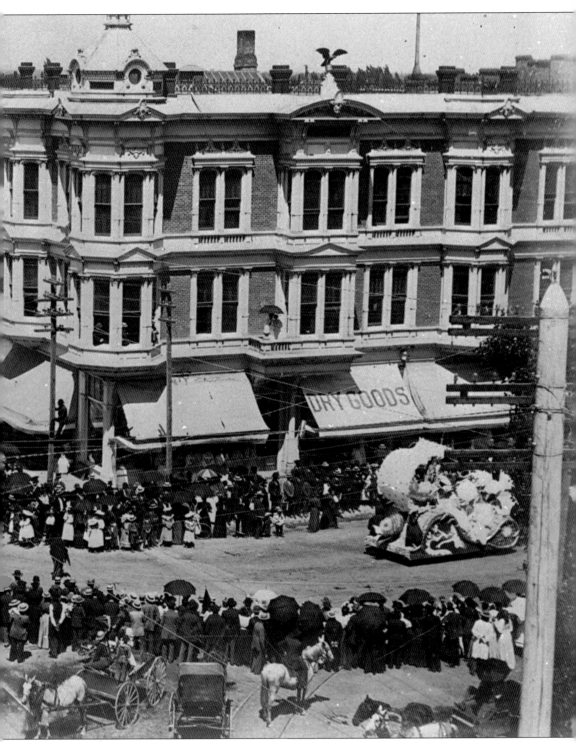

much needed first-class lodging for many Ogden visitors. The building was razed in 1958 to make way for the current Key Bank building. (Courtesy of Union Station.)

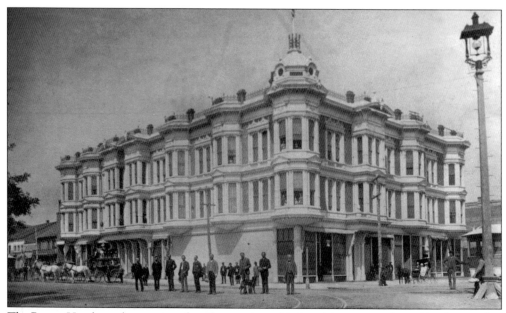

The Broom Hotel was the meeting place for prominent Ogden citizens, as evidenced by those in this photograph including, from left to right in front center, two unidentified, John Ellis, J.M. Dee, Charles J. Rapp, Joseph Clayton, John B. Tyler, J.W. McNutt, and John Broom. Also pictured are S.H. Giesy, E.A. McDaniel, J. Percival Barratt, Ada Barrett (in wagon), George F. Brown (rear center), Hester Dunsdon Broom, O.F. Brown, John C. Brown, and Mrs. Eliza Broom Wellon. (Courtesy of WSU.)

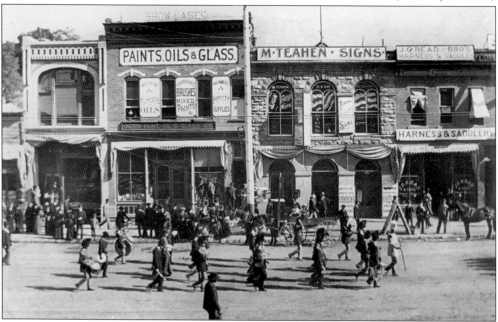

Parades were a common site along the streets of Ogden, a custom still adhered to today with Pioneer Day, Christmas, and Veterans Day Parades. This parade passes along the 2400 block of Washington Boulevard. Although only one of these buildings on the east side of the street still stands, the character, excitement, and the direction of parade travel along Washington Boulevard have changed very little. (Courtesy of Union Station.)

Ogden's rails gave the city a favorable geographic and economic position, which in turn generated a great deal of political influence. Politicians often came through Ogden—a major stop on their railcar campaign tours. In this classic photograph, William Jennings Bryan visits Ogden during his 1896 campaign. (Courtesy of WSU.)

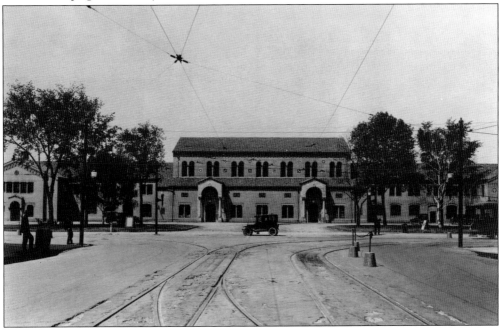

Following the fire that destroyed the original Union Depot, the New Union Station was completed in 1924. This photograph highlights the beautiful detailing of the Early Christian/Byzantine Revival architectural style of the new station designed by Los Angeles architects Parkinson and Parkinson. Trolley tracks and catenary wires crisscross the west end of Twenty-fifth Street, where many passengers transferred from one form of railway transportation to another. (Courtesy of WSU.)

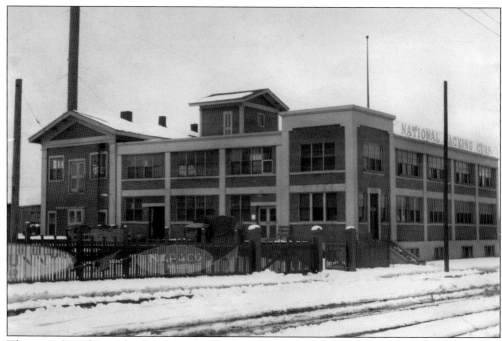

The area directly north of downtown developed into an industrial district with packing and canning businesses, viable because of their proximity to the rail yards. The streetcar barns were also located in the neighborhood, some of which are still intact today. The National Packing Corporation shown here was one of many businesses taking advantage of the location near both streetcar and rail lines. (Courtesy of WSU.)

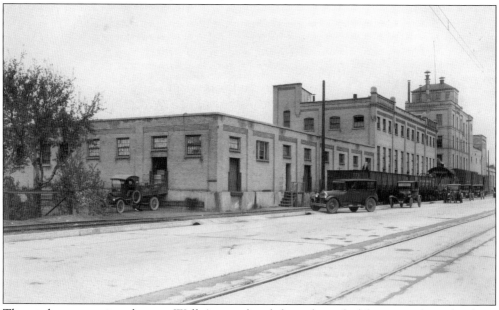

The poultry processing plant on Wall Avenue lined the rails, with delivery trucks and railcars surrounding the building. Note the streetcar tracks in the ground and power lines overhead, indicative of the industrial applications of railways. In addition to poultry, Ogden's livestock industry was also fueled by the city's proximity to rail. (Courtesy of WSU.)

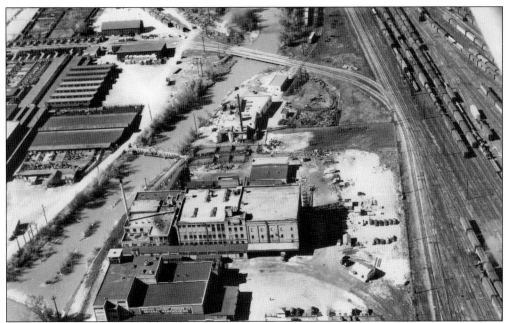

Ogden's prominence as a railroad hub and central-western location made it ideal for a livestock exchange. These images show expansive livestock facilities. By 1929, Ogden was the largest livestock market west of Denver, processing over 250 carloads of cattle, 200 carloads of sheep, and 100 carloads of hogs every single day. The Swift meatpacking plant was the largest sheep and lamb processing plant in the nation in 1934. In addition to the stockyards, the Golden Spike national livestock show was renowned throughout the west as the premier livestock exposition, representing 20 states and Canada. The aerial image above shows the American Packing & Provision complex and the west edge of the busy transcontinental rail yards, along the banks of the Weber River. The below view of the stockyards looks east toward the Ogden River and the American Packing & Provision buildings. (Both, courtesy of WSU.)

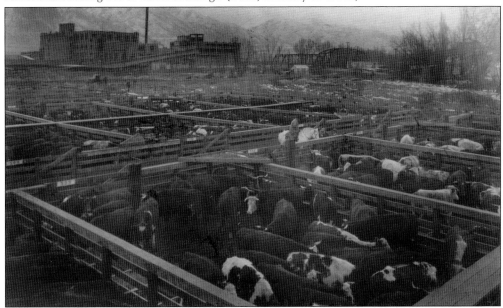

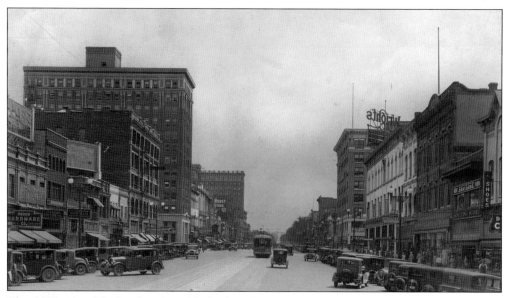

This 1928 view of the bustling 2300 block of Washington Avenue shows the rise of the automobile in the urban scene. While the streetcar remained a viable mode of transportation for many residents, it had to compete with the convenience of automobile ownership. In 1928, the price for a Model A ranged from $385 for a roadster to $1,400 for a top-of-the-line Town Car. Gasoline was around 21¢ per gallon. (Courtesy of WSU.)

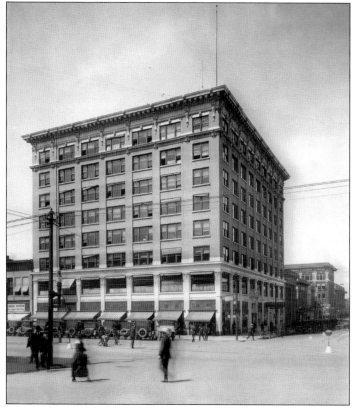

The David Eccles Building on the southwest corner of Washington Boulevard and Twenty-fourth Street is an excellent example of the Second Renaissance Revival style, blending Prairie style elements with classical motifs. Designed by Leslie S. Hodgson and constructed in 1913, the building is preserved today as a part of the Eccles Conference Center, joining the hotel and Egyptian Theater. The streetcar tracks along the west portion of Twenty-fourth Street are seen here ending at Washington Boulevard. (Courtesy of WSU.)

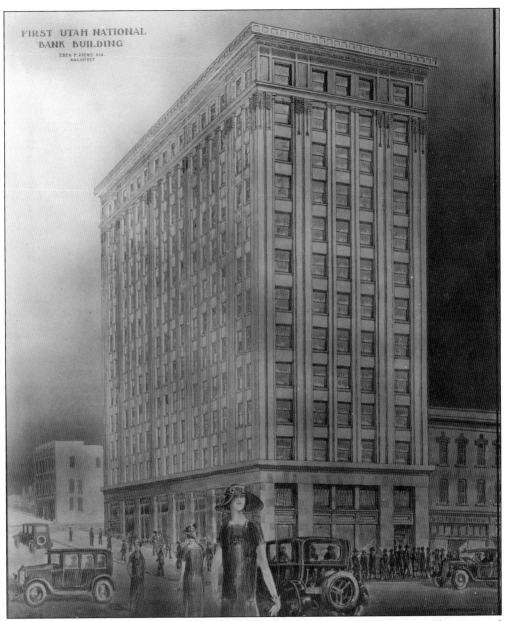

FIRST UTAH NATIONAL
BANK BUILDING
EBER P PIERS AIA.
ARCHITECT

The First Security Bank, at Twenty-fourth Street and Washington Boulevard, stands as a visual gateway to the streetcar neighborhood to the east. Designed by Eber Piers, this 1927 architectural illustration captures the style of the 1920s. In 1924, Marriner Eccles and his brother, George Eccles, joined with the Browning family in Ogden to form the Eccles-Browning Affiliated Banks. The bank acquired control of 17 locations in Utah, Idaho, and Wyoming, within a short three-year period. In June 1928, Marriner and George Eccles and E.G. Bennett of Idaho Falls organized the First Security Corporation as a holding company, believed to be the first multi-bank holding company in the United States. As president, Marriner Eccles was the leading banker in the Intermountain West. In 1930, the Great Depression wreaked havoc on banks throughout the nation, but First Security withstood serious runs on its parent bank in Ogden under the leadership of the Eccles brothers. (Courtesy of WSU.)

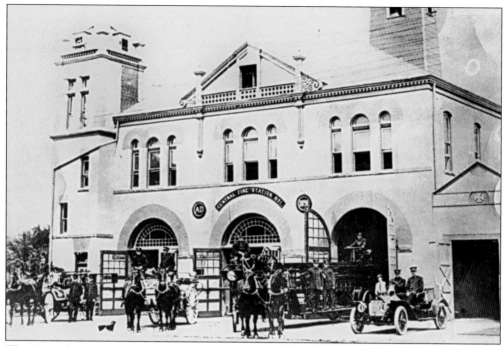

The Central Fire Station was built in 1891 to protect the new homes in the Trolley District from damaging fires. The early horse-drawn fire engines eventually gave way to automotive fire engines. Fire was perhaps the biggest threat to life and property in the early days, with the prevalence of wood construction and the use of wood-burning stoves leading to many mishaps. Over time, fire turned out to be the biggest enemy to historic preservation, as homes often burned down before the engines could arrive. Below, the straight-on view of the station shows the horse-drawn cart in contrast to the three automotive fire engines. (Both, courtesy of Union Station.)

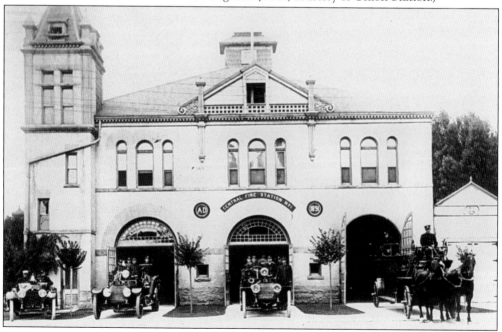

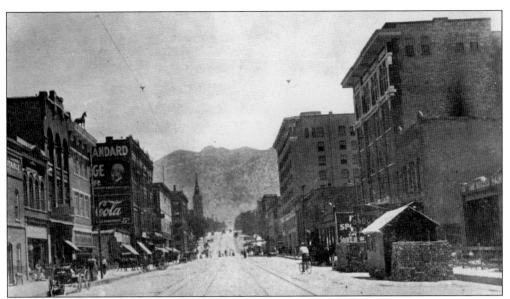

This rare 1914 view looking east on Twenty-fourth Street shows the streetcar tracks on the lower portion of the street as well as several key buildings. The David Eccles Hotel (middle right) housed several local businesses including Fred M. Nye's famous department store. The Kiesel Building (tall structure at right) was home to the *Ogden Standard Examiner* from the 1920s until 1961. (Courtesy of Union Station.)

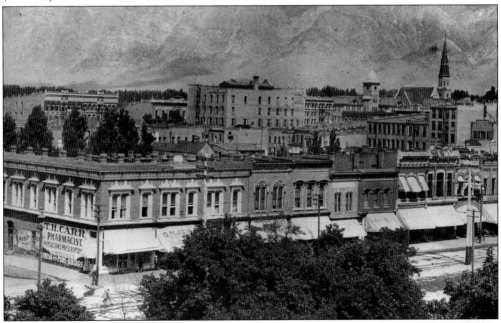

This view shows the north side of the 300 block of Twenty-fifth Street looking northeast. A sign for T.H. Carr Pharmacist indicates some of the commercial presence on the street. Thomas H. Carr was a prominent Trolley District resident who built a home on the 2500 block of Jefferson Avenue. The home, a craftsman brick bungalow with ornate decorative glass windows depicting the famous Mormon crickets still exists at 2520 Jefferson Avenue. Carr was a very tall man, and his custom-ordered seven-foot-long bathtub remains operational. (Courtesy of Union Station.)

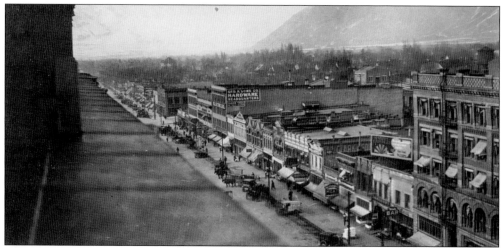

This view from Twenty-fourth Street and Washington Boulevard looking northeast was taken from the former Eccles Building. This entire block (on the left) was razed to make room for the Ogden City mall in 1980. Here, the east side of the street is packed with commercial storefronts and the Trolley District rises up the hill in the background. (Courtesy of Union Station.)

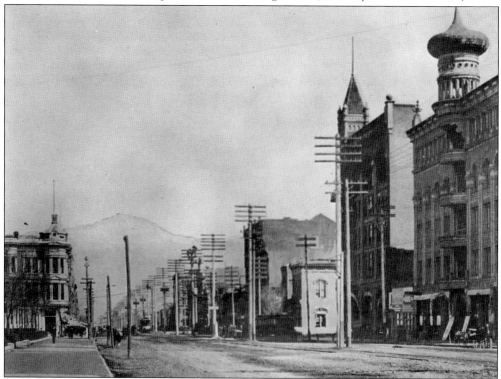

Adjacent to the Bigelow Hotel sat the Orpheum Theater, built in 1890 and originally known as the Grand Opera House. According to Cathy Free in a September 4, 1983, *Salt Lake Tribune* article, the theater's construction was funded by "three of Ogden's leading citizens, who were embarrassed that the railroad hub of the Rockies didn't have a decent playhouse." The first performer at the Orpheum Theatre was Emma Abbot, "the prima donna of the world's stage," who died one week later. (Courtesy of WSU.)

Two

TRACKS AND TROLLEYS
AROUND OGDEN

Beginning in 1875, a group of citizens petitioned the city council for a franchise to build a mule-drawn street railroad and the petition was denied. Two years later, another petition was presented and granted, but was never used. In 1883, the Ogden City Street Railway Co. was incorporated. In August of that year, it was granted permission to construct and operate Ogden's first city rail line. Grading began on March 27, 1884, with the first car rolling on May 15, 1884.

The original system consisted of three mule-drawn cars. There are many great stories about runaway mules and the frustrated mule-drivers who operated these early trolleys. When the streetcar reached either end of the route, the teams were unhitched and brought to the other end of the car, rather than turning the car around. The streetcar system transitioned to small steam engines by 1889, mainly for the longer routes to Harrisville–Plain City and up the canyon. In 1890, the system was sold to Jarvis-Conklin, which was a mortgage company from the Midwest. In 1891, an electric streetcar made its appearance on Ogden City streets.

Businesses arose daily around streetcar lines, offering everything from building materials to shirts. Ogden became the hub of the West for the manufacturing of dry goods, with some of the finest clothing lines beginning here. Operations of Fred J. Kiesel, the Kuhn Brothers, and the John Scowcroft enterprises were based in Ogden. The Amalgamated Sugar Company and other business ventures of David Eccles began in Ogden as well. The most prominent of Ogden-based businesses was the Utah Construction Company, founded by David Eccles, the Wattis brothers, and Thomas Dee.

The trolley system grew, and streetcars were built nearly every two blocks, including east-west routes on every other block between Twenty-first and Twenty-seventh Streets. The streetcars coexisted with horses, pedestrians, and eventually, numerous automobiles, as they moved through the neighborhoods. Much of the system was further developed into the Trolley District under the direction of the Ogden Rapid Transit Co. with Edmund G. Vaughn as the executive vice president. In 1900, David Eccles of Thomas Dee & Associates changed the name to the Ogden & Northwestern Railway. After several mergers and another split, the Utah Rapid Transit Company emerged in 1920 and operated the Ogden City streetcar system until December 26, 1935, when the company officially discontinued trolley service, transitioning public transportation to buses.

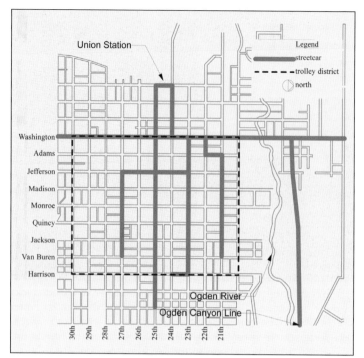

This map shows the actual streets where the tracks were laid. Washington Boulevard, Lincoln Avenue, and Wall Avenue were the main north-south routes, with the tracks running east-west approximately two blocks apart. Even today, development is mostly within a quarter-mile of the in-ground track, or roughly two blocks. Most residents of the Trolley District only needed to walk one block or less to catch a streetcar.

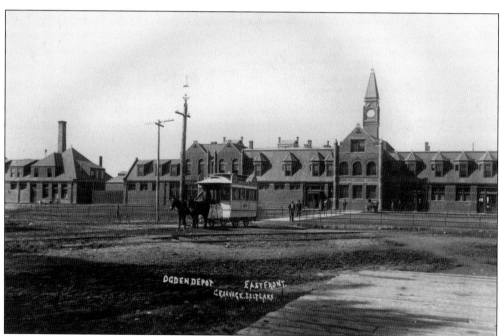

The original Union Depot was serviced by three mule-powered streetcars starting in 1883. This continued through 1890, when the transition to overhead electric power was complete. According to Milton R. Hunter in *Beneath Ben Lomond's Peak: A History of Weber County, 1824–1900*, streetcar operator John Crossley said, "In the old days we were in direct competition with hacks [taxis] and many times I have trotted my team at a pretty good clip to beat a bevy of cabbies to the station." In the days of horse or mule cars, a change of teams was made every four hours.

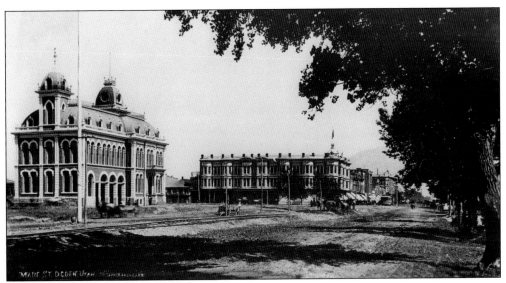

This photograph, taken by C.R. Savage, looks north along the Washington Boulevard tracks under construction and shows early Ogden's city-county building (left) and the Broom Hotel (center). The crown of the road is evident, affecting the placement of the tracks along the wide boulevard. Box elder trees, which have early origins in Weber County, line Washington Boulevard on the east side. The rails were installed in 1884 and the Broom Hotel was built in 1883, dating this photograph to the mid-1880s. (Courtesy of Union Station.)

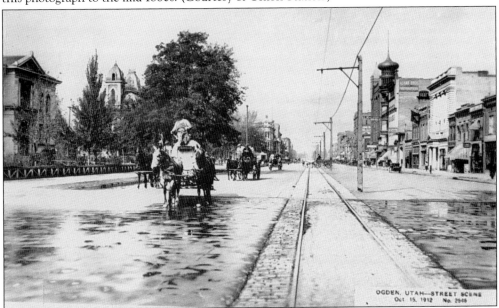

Looking north on Washington Boulevard on October 15, 1912, horses outnumber automobiles despite the fact that the first car was introduced to Ogden 10 years earlier. The paved streets were a great improvement over the muddy roads that Ogdenites struggled with prior to the turn of the century. The Corey Livery & Stable building, at far right, was built only two blocks away from Amos and Eva Corey's home at 2601 Jefferson Avenue. Recently converted from a five-plex back to a single family residence by Tyler and Jessica Hollon, the home shines again as a gem in the Trolley District. (Courtesy of Union Station.)

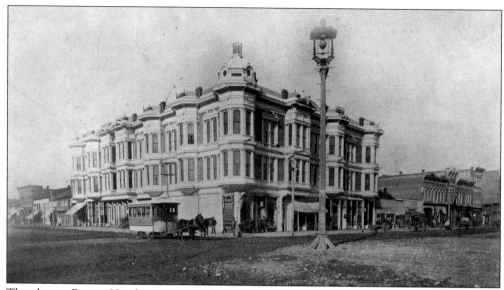

The elegant Broom Hotel contrasts with the dirt streets and the mule-drawn streetcars of early Ogden. After the advent of the railroad in 1869, it quickly became apparent that the city was lacking in hotel accommodations. Several were built but none so important to Ogden's reputation as the Broom Hotel. Built in 1882 by John Broom, it was made of the best fireproof brick and was exquisitely decorated with crystal skylights, rooms with their own private baths, and large double-bay windows supported with Corinthian columns. The advent of the streetcar service to this corner enabled Ogden to provide worldly travelers superior comfort coupled with the convenience of transportation from the Union Depot to the front doors of the hotel. Below, mules and their streetcar wait for passengers. (Both, courtesy of Union Station.)

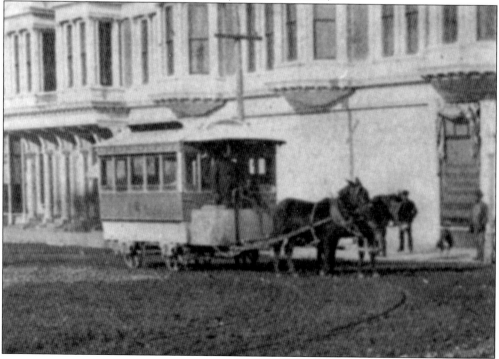

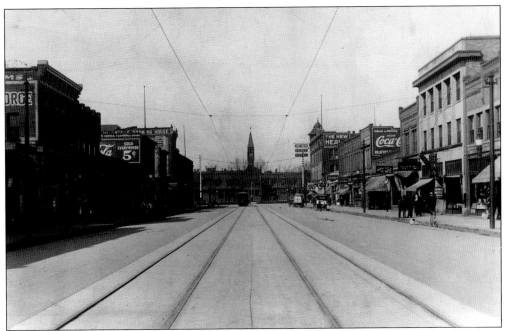

This photograph captures the twin rails going down Twenty-fifth Street toward the old Union Depot. The Windsor Hotel, formerly known as the Van Ness Hotel, is on the right, along with the Grand Hotel and its Coca-Cola sign, which are both still intact today. By this time, electrification of the streetcar system had taken place and mules were no longer used. (Courtesy of WSU.)

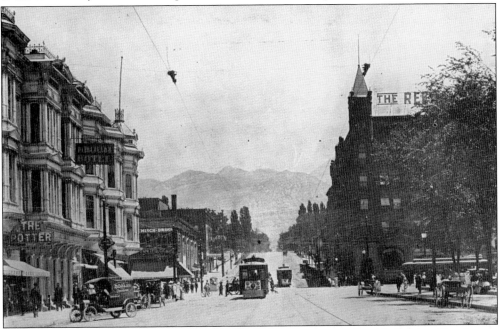

The Broom Hotel (left) and the Reed Hotel (right) gave visitors comfortable lodging. Hotels were a sparse commodity until the meeting of the rails at Promontory, when an influx of cross-country travelers created a new demand for comfortable accommodations. The fame of these particular hotels spread rapidly, attracting many east-west travelers. (Courtesy of Union Station.)

The Reed Hotel, built in 1891, replaced the White House, so named because of its white-painted adobe construction. The latter was originally built in 1868 along with the Ogden House, one block north. Seven hotels along the tracks served Ogden from 1869 on. (Courtesy of WSU.)

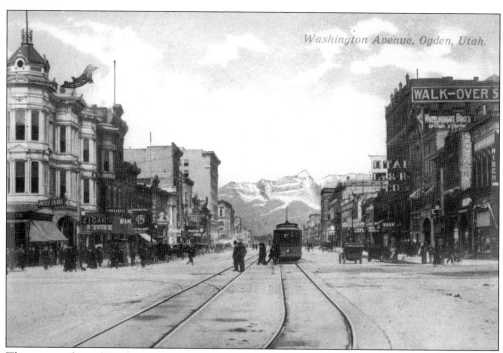

This winter shot of Washington Boulevard, looking north to Ben Lomond Peak, shows the sheer numbers of riders serviced by streetcars. Ogden citizens rode the streetcar to the central city for work, shopping, and socializing. Often, winter conditions required the sweeping of the tracks after a big storm, with sand sprinkled down for traction. The trolley poles that connected the cars to the overhead power supply often became disconnected, so the conductors kept long sticks to re-attach them to the catenary wires. (Courtesy of Union Station.)

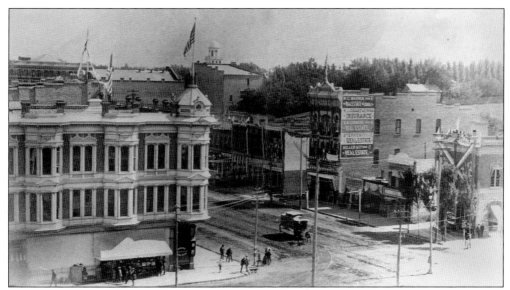

Mule or horse-drawn streetcars were used until the transition to electric in 1891, with a short window of time when small steam engines called "dummies" were used. The paving of Ogden's streets did not begin until after 1889 when Twenty-fifth Street became the first to get asphalt. The process was so successful that within the next 10 years, many streets were paved, eliminating the problems of muddy roads. (Courtesy of Union Station.)

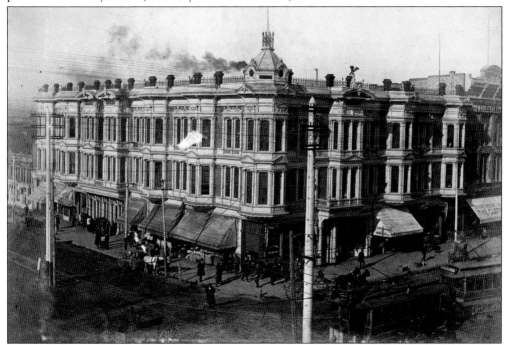

Streetcars round the famous Broom Hotel corner around 1892. This particular view also shows the grocery market on the main floor of the Broom, with bins of produce sitting under the awning. On the adjacent corner was a stationery shop. The 1880s were the boom years in Ogden, with the population growing exponentially until the financial crisis of 1893. A recession followed the panic, ending around the time Utah was admitted to the Union in 1896. (Courtesy of WSU.)

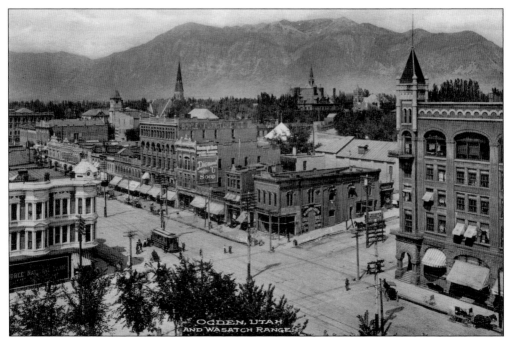

Possibly the most photographed intersection in the city—Twenty-fifth Street and Washington Boulevard—again shows the Broom and Reed Hotels, this time with the streetcar and an automobile in the street with numerous horse and wagon operations. Orlando J. Stillwell purchased the first automobile in Ogden in 1902. It had one seat, pneumatic tires, no brakes, and was steered with a handle. This photograph was taken around that time, given the number of horse-drawn vehicles up and down Washington Boulevard. (Courtesy of WSU.)

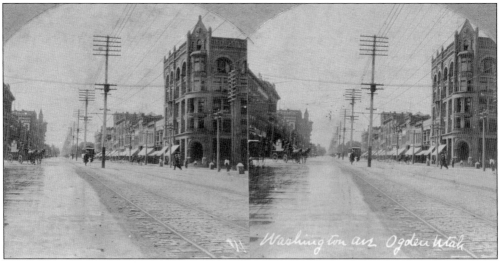

Seen through the dual viewfinder of a stereoscope, this rare view was taken from the corner of Twenty-fourth Street and Washington Boulevard, looking south. In the left distance is the outline of the Reed Hotel, and in the right distance is the Broom Hotel. Based on the mix of electric streetcars and the lack of any noticeable automobiles, this photograph is probably from the mid- to late 1890s. A small child dressed in white with a bonnet is in the middle of the street, and farther down, a parasol-carrying resident crosses the street south of the streetcar. (Courtesy of WSU.)

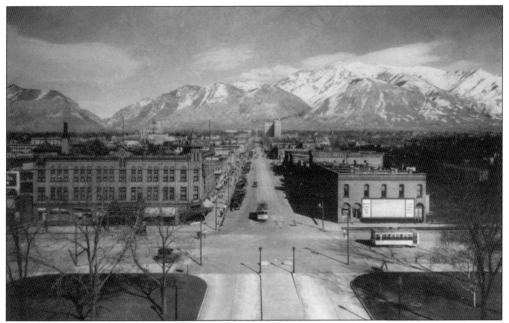

Streamlined 1920s-style streetcars are shown in juxtaposition with the increasingly popular automobile. A combination of socioeconomic conditions led to the demise of Ogden's streetcar system in the 1930s. This image captures the essence of the city at the foot of Mount Ogden. Other than the predominant mode of transportation, seemingly little has changed on historic Twenty-fifth Street. (Courtesy of WSU.)

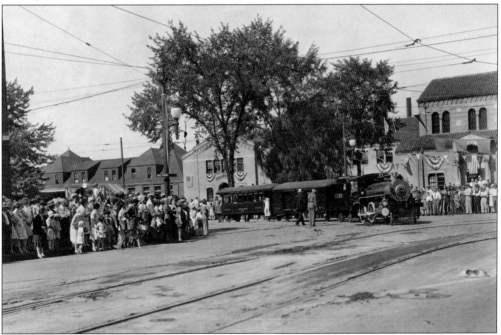

A Union Pacific float rounds the bend in front of the new Union Station in the 1930 Fourth of July parade. Parades were popular social events in Ogden life and, with tracks below and catenary wires above, the streetcars were an integral part of the parade. (Courtesy of WSU.)

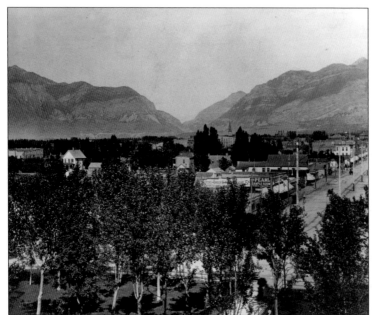

This image, looking up Twenty-fifth Street from the top of the old Union Depot, was taken just before 1900 as the Healy Hotel had yet to be built. Tracks had been installed and the mule-pulled cars were in full swing, with the electric transition imminent. Several photographs were taken from this view in the station, allowing for comparison of the changes taking place in the downtown core. (Courtesy of WSU.)

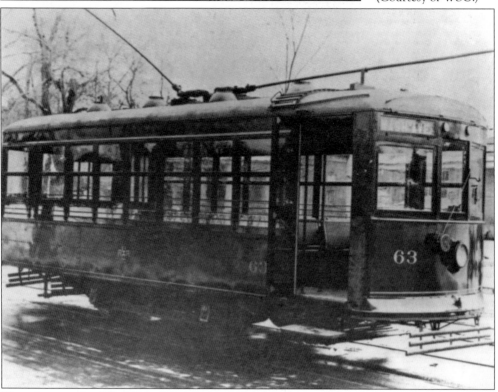

This photograph of Washington Boulevard highlights the trend in streetcar design at the time. The "Birney" was considered the very latest in streetcar transportation in 1919 and 16 of the little cars provided the bulk of Ogden's streetcar services. These heavy steel cars running on steel rails made for a noisy and bumpy ride that is not fondly recalled by many today. (Courtesy of Union Station.)

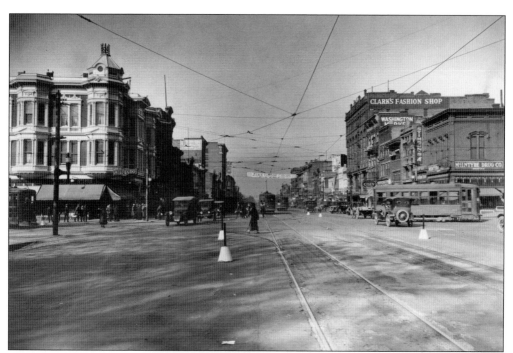

These views of the Twenty-fifth Street and Washington Boulevard intersection show multiple "Birney" model streetcars and several automobiles. The Cozy Theater (above, right) was open for a short time between 1918 and 1922. The Boyle Furniture Building turned into Clark's fashion shop, one of many Ogden businesses to change hands from the mid-1890s forward, when economic conditions wavered and stabilized, booming yet again just prior to the Great Depression of 1929. The image at right shows the Broom Hotel (left) and Hotel Bigelow (right) in the midst of winter. (Both, courtesy of WSU.)

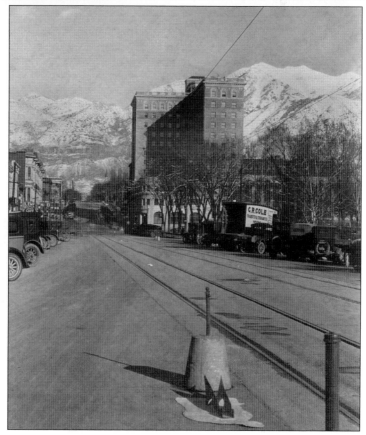

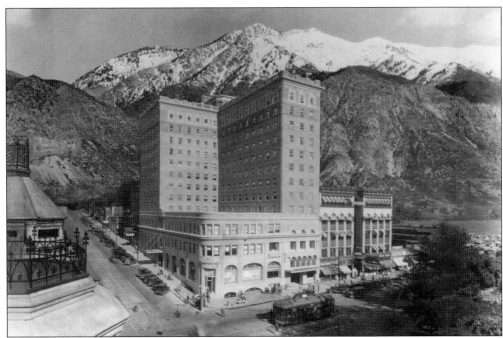

In 1927, A.P. Bigelow razed most of the former Reed Hotel and built a first-class hotel in the opulent style of the Roaring Twenties. The first three floors of the Reed were incorporated into the new structure, which also included a tower designed for the Bigelow family's private residence. Designed by Hodgson & McClenahan in the Italian Renaissance Revival style, the hotel remains a rare and exquisite example of the style in Utah. The hotel was renamed the Ben Lomond in 1933 by then-owner Marriner S. Eccles in honor of his Scottish homeland, and the name endures today. Below, the Bigelow stands in the background as a lone streetcar heads east on Twenty-fifth Street. Note the old 1889 city-county building on the right, which eventually fell to the wrecking ball in 1939 to make room for the Ogden Municipal Building. (Both, courtesy of WSU.)

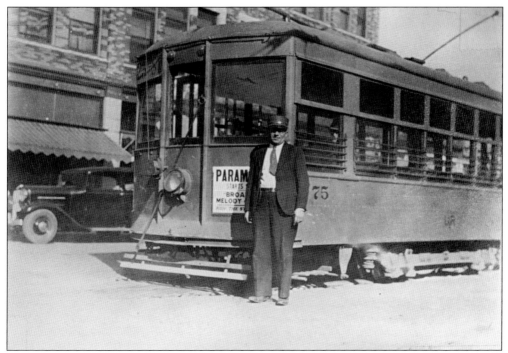

This image, dated Oct 19, 1935, shows Streetcar No. 75 on Twenty-fifth Street in front of the current-day Marion Hotel. Exactly two months and six days later, streetcars ceased operations in Ogden and the transition to the world of the automobile was complete. (Courtesy of Union Station.)

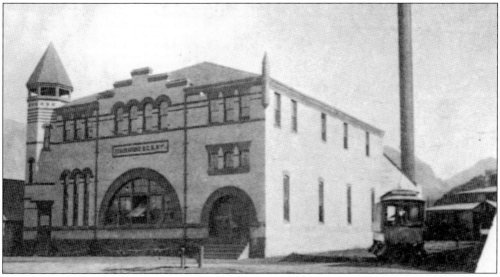

The Ogden Street Railway Powerhouse is seen here in its glory days. Begun as the Ogden City Railway, it changed several times and eventually transformed into the Ogden City Street Railway. During the streetcar years, several entities tried to get in on the biggest transportation business of the day. The various companies fought over track-laying rights, sued each other, had accidents between the streetcars, and eventually, the smaller, under-capitalized companies lost their bids to take over the rails. Reading through the drama-laden history of the active streetcar times bears a strong resemblance to the resurgent streetcar activities of today. (Courtesy of Union Station.)

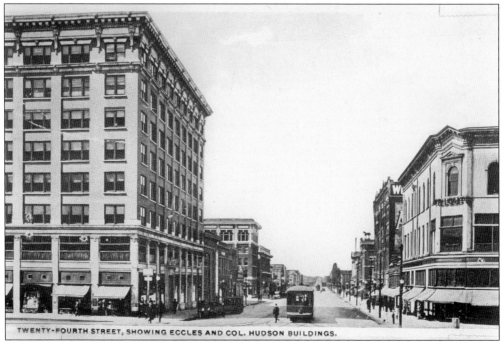

TWENTY-FOURTH STREET, SHOWING ECCLES AND COL. HUDSON BUILDINGS.

The highly controversial tracks on Twenty-fourth Street were installed and operated by the Ogden Street Railway, but it would take a judge's decision to force the multiple streetcar companies not to interfere with each other's operations. This view from Washington Boulevard looks west on Twenty-fourth Street at the Eccles and Col. Hudson Buildings and show a blend of people, automobiles, and streetcars. (Courtesy of Union Station.)

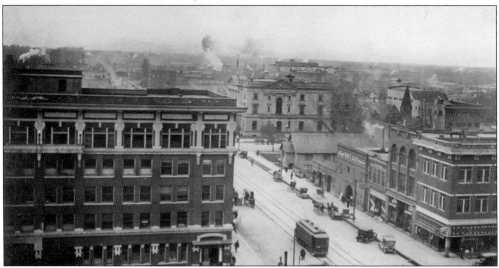

The view on this postcard is from the top of the David Eccles Building at Twenty-fourth Street and Washington Boulevard and shows the Kiesel building, built in 1913, which still stands today. Across the street is the spire of the Episcopal church as well as the old post office, built in 1907. Although the automobile was introduced to Ogden in 1902, horse-drawn transportation continued in the commercial sector into the early 1920s. The large Scowcroft warehouse in the distance was renovated in 2004 by the Internal Revenue Service for their Ogden center. (Courtesy of Union Station.)

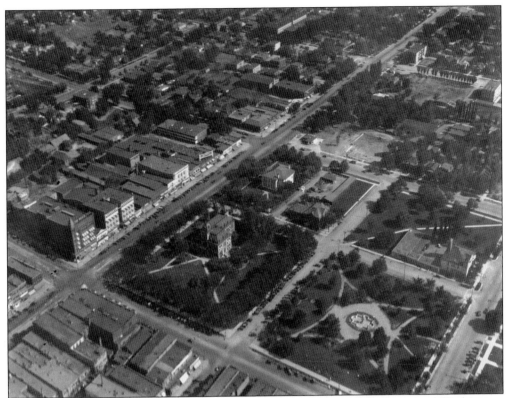

This 1920s aerial view of Ogden shows the intersection of Twenty-fifth Street and Washington Boulevard on the lower left, with the Bigelow hotel and the old city-county building. The municipal block was subdivided by a half-block street in each direction and included a Carnegie library and elaborate civic gardens. (Courtesy of WSU.)

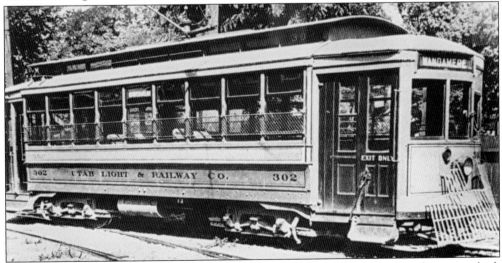

This car, operated by Utah Light & Railway, is pictured en route to Wandermere, a long-ago suburb of Salt Lake City. Across Utah, the cars were very similar to the ones cruising the streets of Ogden, where transit-driven development spurred the growth of the city by connecting neighborhoods. (Courtesy of Union Station.)

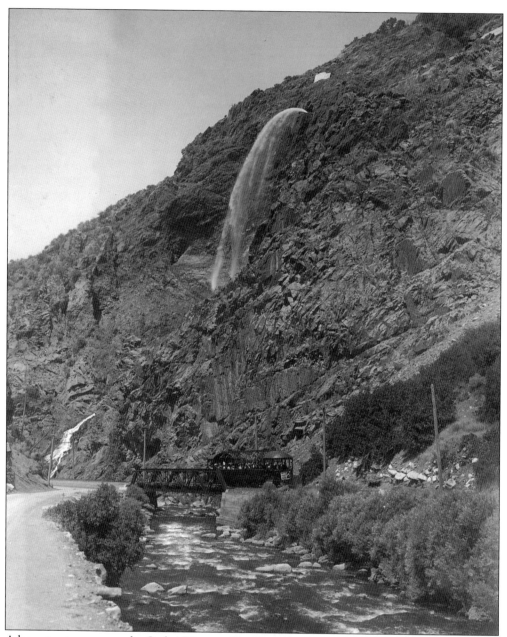

A lone streetcar crosses the Ogden River and heads up the Ogden Canyon line with the waterfall behind it. The waterfall is a man-made scenic attraction caused by the overflow of the river, which still flows today. The trip up the canyon was often taken in open-air cars when weather permitted, giving the passengers full views of the world-class outdoor scenery. During the first season of operation in 1910, the Fourth of July holiday saw roughly 7,000 people transported up the new Ogden Canyon line to the Hermitage resort. During the week, about 900 passengers were carried per day, with the numbers increasing on Saturdays and holidays to nearly 1,800 passengers. From June through August, a car operated every 20 minutes, while in the winter, cars ran every 80 minutes. The Canyon line was the main vacation corridor for Ogden citizens, who often spent summers in the canyon and the Ogden Valley. (Courtesy of WSU.)

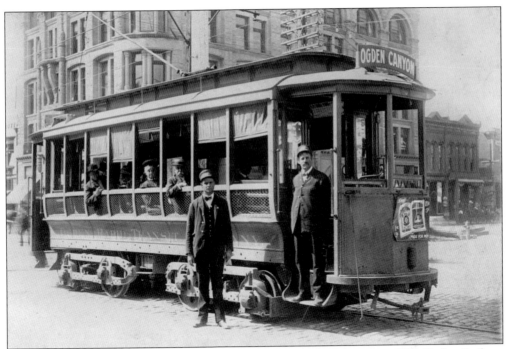

Conductors pose with an Ogden Canyon line streetcar before departure. The Ogden Railway Company completed the line up the canyon all the way to Huntsville in 1915. The total length from end to end—from Union Depot to Huntsville—was about 15 miles. Cobblestones line the tracks. (Courtesy of Union Station.)

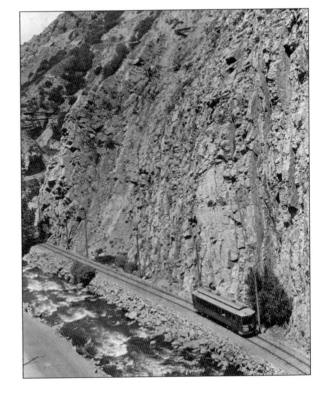

This excellent shot of the Ogden Canyon line shows the scenery passengers enjoyed while traveling this route. The overhead view of the car in the canyon also emphasizes the steep canyon walls carved out to create the path for the rail line. Hugging the north wall, the views into the river were spectacular, as they are by car today. (Courtesy of WSU.)

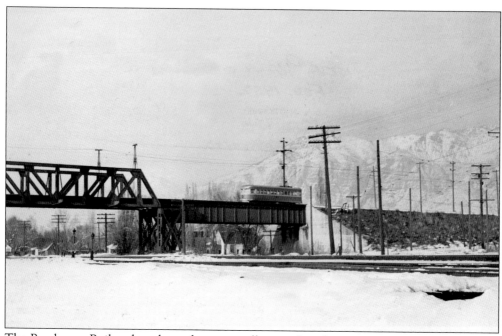

The Bamberger Railroad, perhaps the most well-remembered streetcar inter-urban railroad in Utah, provided service from Salt Lake City to Ogden from 1910 through 1952, going through many renditions of car styles and models. Here, a streetcar crosses the bridge leading into the Ogden rail yard, a traverse now frequented by the FrontRunner. (Courtesy of WSU.)

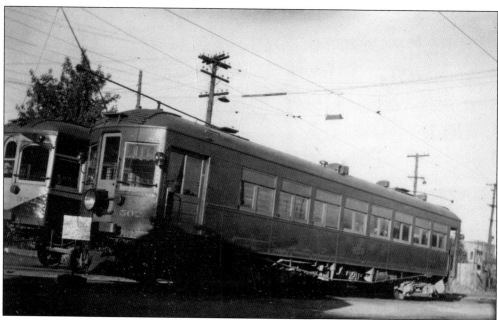

Prior to becoming the Utah Idaho Central Railroad, this line was known as the Ogden, Logan & Idaho Railroad, which merged the streetcar and urban lines of the two David Eccles companies, one from Ogden and one from Logan. The line lasted until 1938. (Courtesy of WSU.)

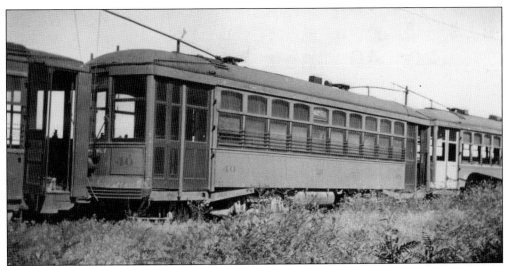

The last of the Utah Idaho Central cars sits in the boneyard. Most of the streetcars were used for scrap metal during World War II. Several cars from the lines still sit just south of the Weber County fairgrounds. Original streetcar models similar to these are still operational in some cities, including San Francisco and New Orleans. (Courtesy of WSU.)

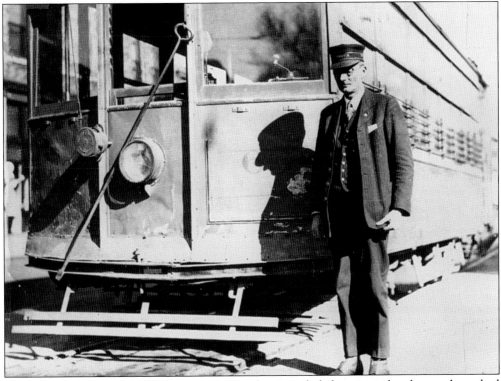

The typical uniform of the Ogden streetcar conductor included a vest, jacket, hat, and starched shirt. This conductor at Twenty-fifth Street and Wall Avenue waits for his next carload of passengers. The rod on the front of the streetcar was used to reattach the power pole atop the car in the event that it became dislocated from the electric wires overhead—a common occurrence. (Courtesy of Union Station.)

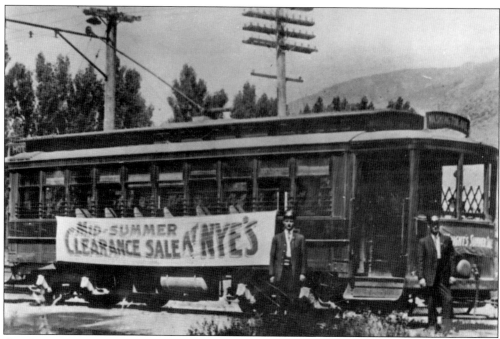

Car No. 33, en route to Huntsville along the Ogden Canyon line, is adorned with an advertisement for Fred M. Nye's summer sale. The motorman on the left is Frank K. Miller, with motorman Foss Wardleigh to the right. The conductor is Elmer Shaw, who is not directly visible. Fred M. Nye was a Trolley District resident, living at 2546 Jefferson Avenue. Owning a successful business in the downtown core was just one of the benefits of the Trolley District—living so close to one's work. (Courtesy of Union Station.)

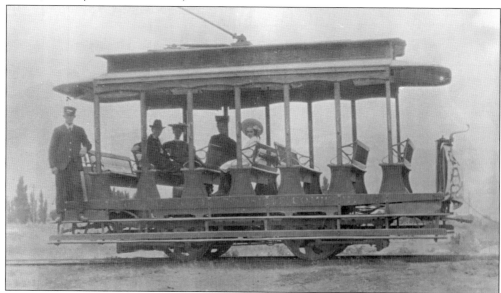

Ogden became the origin and destination of regional streetcar systems, including this one at 2600 North Street and Washington Boulevard, believed to be on the North Ogden line. Lamoni Hulmes is listed as the conductor. The open-air cars offered the passengers the benefits of unobstructed scenery, fresh air, and the sounds of the streetcar. (Courtesy of Union Station.)

Three

OGDEN'S STREETCAR NEIGHBORHOOD

At the end of the 19th century, Ogden's rapidly growing population was clamoring for more housing. The first bench directly east of the city offered a prime location, with close proximity to the businesses of Twenty-fifth Street and Washington Boulevard. As the popularity of the downtown streetcar grew, the new construction of homes on that first bench mandated streetcar line expansion. Advertisements often mentioned the streetcar in marketing properties on the bench. An 1887 newspaper article from the *Ogden Herald*—the predecessor to the *Standard Examiner*—reads:

> Some of the best residence property of the city is on the Bench; and people are looking more and more to that locality for homes. But busy men, who have neither time nor inclination to walk magnificent distances, find great difficulty in accommodating their necessities to the existing condition of affairs. An early extension seems to be requisite, both for the financial interest of the street railway company and for the convenience of the public.

In the era before the advent of the automobile, streetcars were a popular urban alternative to horse and buggy. Trolley routes made the land on the first bench east of the city accessible. The expansion of streetcar lines into the first bench coincided with the development of homes, apartments, and a mix of commercial uses. By 1915, streetcar lines were located on Twenty-first, Twenty-third, Twenty-fifth, and Twenty-seventh Streets, with several north-south connecting lines, including the Jefferson Avenue line between Twenty-fifth and Twenty-seventh Streets. In fact, the streetcar was so commonplace in the Trolley District that it apparently did not occur to any residents to capture images of the streetcars in photographs. Any photographs of streetcars in this chapter seem to be incidental images of streetcar lines accompanying photographs of prominent mansions or general street scenes.

However, the stories gathered about seeing or riding the streetcar are numerous. Robert Asael "Ace" Farr explained that for 25¢, he could ride the streetcar from Harrison Boulevard & Twenty-seventh Street, near his home on Twenty-eighth, downtown to the cinema—buy popcorn, a drink, and the movie—and take it back home. Others have said it was the noisiest form of transportation around. Still others were witness to the circus streetcars taking animals up Twenty-third Street near Eccles Avenue.

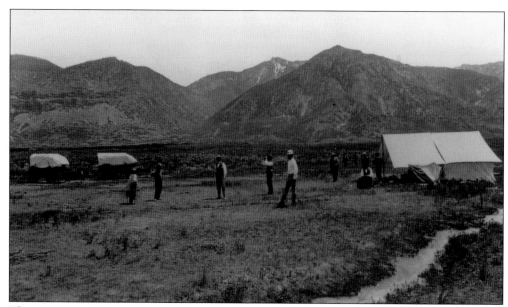

The 1871 US geological survey began its journey to Yellowstone in Ogden. The crew, led by F.V. Hayden, set up camp on the first bench of Ogden one mile directly east of the junction, near the intersection of Twenty-fifth Street and Monroe Boulevard, according to topography charts and elevation data. (Courtesy of WSU.)

By the mid-1880s, much of the Trolley District was somewhat settled, but still offered a rural setting. The home on the left was built by William P. Jones, a local builder, as early as 1882. In 1890, the home was occupied by Joseph Nye. A prominent home for its era, it featured eclectic Victorian scale and detailing. The other homes are simpler pioneer-era structures and the landscape features rural roads, fences, and distant orchards. (Courtesy of WSU.)

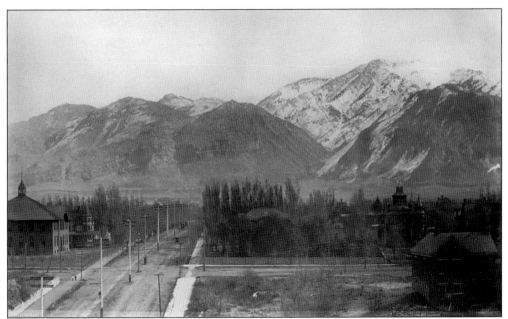

Between 1887 and 1890, the streetcar expanded into the Trolley District, with the first cars powered by teams of mules. The line up the hill between Washington Boulevard and Adams Avenue required an extra mule to make the grade, especially in the winter months. These scenes from around 1900 show a single set of streetcar tracks and overhead catenary wires strung over an unpaved Twenty-fifth Street. The above image looks east into the district across the intersection of Twenty-fifth Street and Adams Avenue. The image below looks back down Twenty-fifth Street with the original Union Depot in the distance. (Both, courtesy of WSU.)

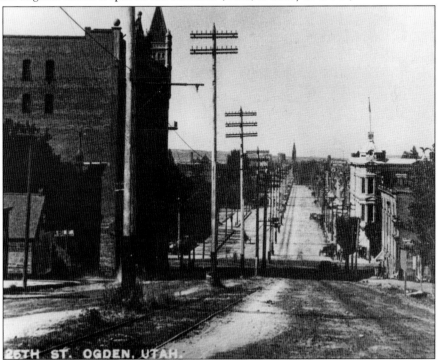

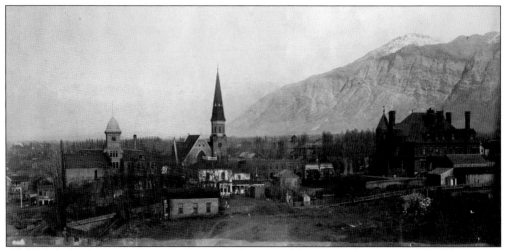

The spire of the Methodist-Episcopal (M.E.) church punctuates this view overlooking the inside of the block between Twenty-fourth and Twenty-fifth Streets and Washington Boulevard and Adams Avenue. Also visible are the courthouse on the left, and the David Peery Mansion, also known as the "Virginia," on the right. The perspective provides a glimpse into the backyard life of the district, including outbuildings, privies, and fences. (Courtesy of WSU.)

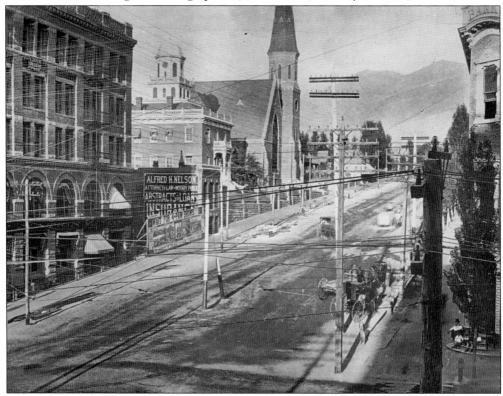

Looking through a tangle of wires strung across the intersection of Twenty-fourth Street and Washington Boulevard, the courthouse and the M.E. church are seen on the north side of the street. This view to the east up Twenty-fourth Street shows that the streetcar tracks on the downtown portion of Twenty-fourth Street did not continue up the hill here. (Courtesy of Union Station.)

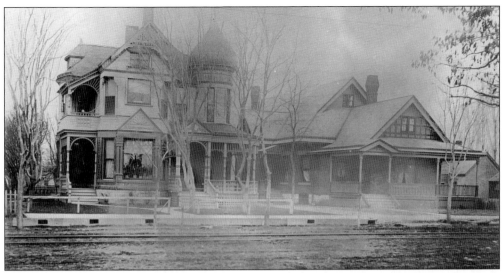

This elaborate Queen Anne–style Victorian home sits adjacent to a more traditional picturesque-style house on the 700 block of Twenty-fifth Street. Both homes feature porches, multiple gables, and ornate woodwork. At 726 Twenty-fifth Street, the "onion dome" Victorian was built by Andrew J. Warner in 1890. Next door, at 730, is the O.A. Parmley house. The two houses demonstrate the contrasting styles coexisting along the tracks in the Twenty-fifth Street corridor through the center of the Trolley District. (Courtesy of Union Station.)

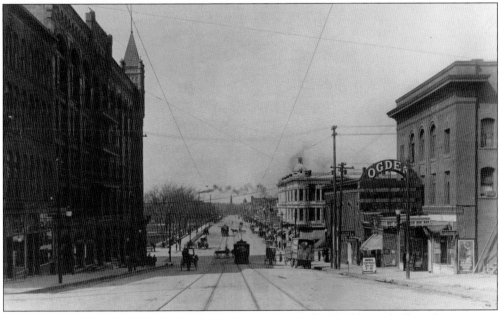

Eventually, the rail line up Twenty-fifth Street was converted to double track when the street was paved. The distant spire of Union Depot, which later burned, is visible in the background. This photograph is most likely from 1915, as the theater to the left features *The Bachelor's Romance*, the 10th movie produced by Paramount Pictures in that year. Paramount was originally a film distribution company founded by William Wadsworth Hodkinson, who had sketched the company logo based on memories of mountains—reportedly Ben Lomond Peak—from his youth near Ogden. (Courtesy of WSU.)

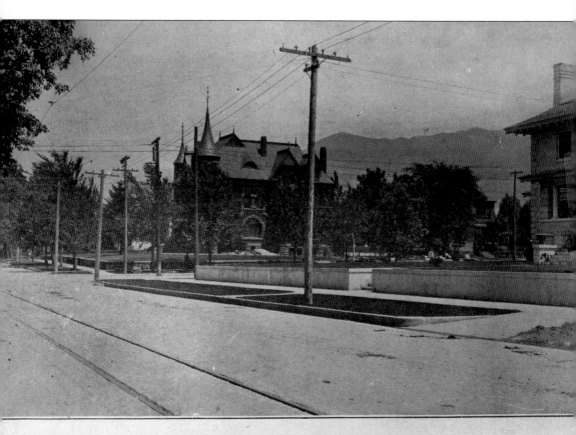

Jefferson Avenue, looking North from Twenty-sixth Street

One of the few north-south segments of the streetcar in the Trolley District was a four-block section along Jefferson Avenue between Twenty-third and Twenty-seventh Streets. The homes in the neighborhood were constructed between 1882 and 1928 and were built for some of Ogden's wealthiest founding families, acquiring the name Banker's Row. The David Eccles Mansion is at center, while a portion of the Pingree Mansion is visible on the right. The line from Twenty-third to Twenty-fifth Streets passed by the dance pavilion at Lester Park, the Weber Stake Academy, and the mercantile of J.R. Horspool at Twenty-fourth Street and Jefferson Avenue. (Courtesy of Union Station.)

Originally opened in the fall of 1896 as the Utah School for the Deaf, this school was opened to all deaf students between the age of 8 and 18. The campus, on Twentieth Street between Monroe Boulevard and Jackson Avenue, now houses the head offices of the Ogden School District. The large building in the foreground was torn down by the district in the spring of 2012. (Courtesy of WSU.)

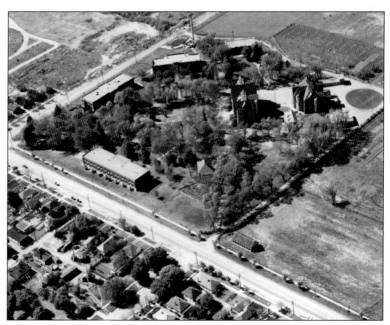

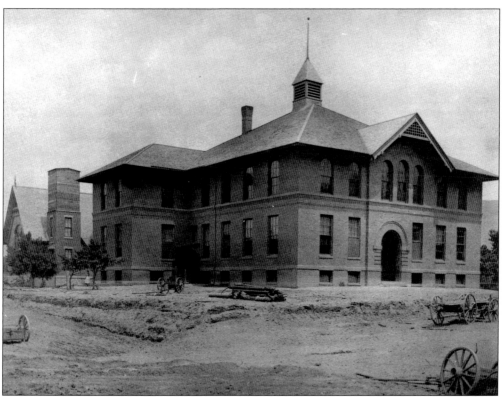

The Ogden Academy was built in 1887 by the New West Education Commission under the direction of the Congregational church on the northeast corner of Twenty-fifth Street and Adams Avenue. This photograph shows the completed building, but the road, trolley, sidewalk, and parking strip appear to be under construction. (Courtesy of WSU.)

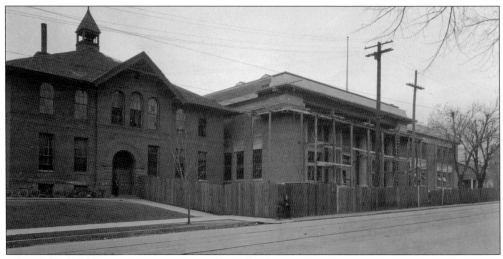

The Weber Stake Academy was originally formed as a church school for the Church of Jesus Christ of Latter Day Saints. The school opened in 1889 with two teachers and 98 pupils, and by 1895, the growth of the school necessitated its relocation to the block between Jefferson and Adams Avenues and Twenty-fourth and Twenty-fifth Streets, where the institution continued its rapid growth, expanding the campus and adding new buildings. In 1916, the church board of education created Weber Academy by adding two upper years to the curriculum, which were eventually dropped. In 1933, Weber College was transferred to the state of Utah and became Weber State University, moving to a new campus in 1954. (Courtesy of WSU.)

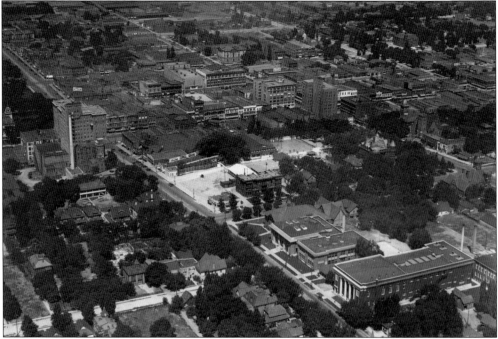

Another early-1920s aerial image of the Trolley District looks northwest across the 500 block of Twenty-fifth Street. The amalgamation of institutional buildings near the center is the Weber Academy, which eventually became Weber State University and is now located at 3848 Harrison Boulevard in Ogden. (Courtesy of WSU.)

Streetcars ran on bustling commercial streets as well as quaint residential streets. This friendly street with a tree-lined canopy, delicate Victorian iron fences, and neighborly front porches shows what life was like before automobiles. (Courtesy of WSU.)

A laborer takes a break from digging underground utilities by hand. There are two sets of track on the unpaved Twenty-fifth Street in this view, looking south toward Porter Avenue, with the Victorian at 529 Twenty-fifth Street in the background. The home has survived the test of time, sitting patiently at the corner of Twenty-fifth Street and Porter Avenue. (Courtesy of WSU.)

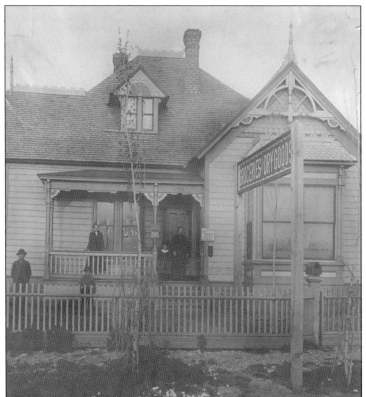

The George Poulter home on Gramercy Avenue is an excellent example of a cozy pioneer house also used as a small mercantile. Businesses were often operated out of the front of the building, such as this house at Twenty-sixth Street and Van Buren Avenue, which was formerly a mercantile in front and a home in the rear. (Courtesy of Union Station.)

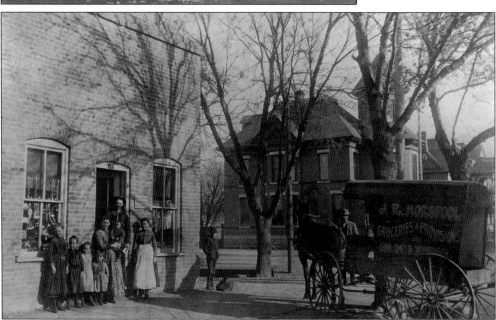

Small mercantile businesses like J.R. Horspool Groceries and Provisions on the northwest corner of Twenty-fourth Street and Jefferson Avenue provided convenient access to the bustling population of the central bench. Closer examination of this photograph reveals the in-ground rails on the 2300 block of Jefferson Avenue. (Courtesy of Union Station.)

Today, Ogden celebrates the coming of snow and residents of the Trolley District dawn their winter gear and head up to the bench and Ogden Valley for skiing and other snow sports. Winter engulfs Ogden for four to six months each year, and while the streetcar ran rain or shine, snow was a difficulty for the early railways. The tracks would have to be swept and dusted with sand to help provide the friction necessary to make the steep grades heading up into the Trolley District. The image below appears to have been taken somewhere near Monroe Boulevard on Twenty-fifth Street, based on the perspective of the mountains in the background. (Courtesy of WSU.)

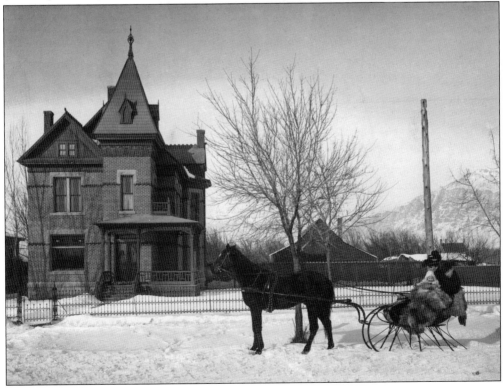

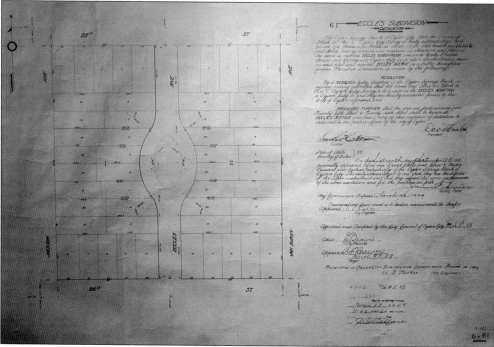

If Jefferson Avenue was the first banker's row, Eccles Circle was the second, located directly east of the first premier neighborhood. The land that the district now sits on was originally owned by Ogden's first mayor, Lorin Farr. In 1893, David Eccles acquired the property and employed architect Leslie S. Hodgson to lay out the plat for a subdivision. The street splits, creating a large elliptical median now known as Watermelon Park, a defining feature along with its Sycamore-lined park strips. The intimate scale of the neighborhood, along with the shared oval lawn and park-like front yards flowing freely together, undivided by fences or walls, embodies the landscape ideals of the Arts & Crafts period in which it was designed. The district is seen here soon after it was constructed, before the planting of the sycamore trees that are now such iconic elements of the neighborhood. (Above, courtesy of Thomas Moore III; below, courtesy of WSU.)

The McGregor Apartments on the corner of Twenty-fifth Street and Monroe Boulevard typify the three-story brick structures of the early 1920s reminiscent of the popular Prairie style that sprang up all over Ogden to satisfy the burgeoning population. Most of these buildings still stand; they were all added to the National Register of Historic Places in 1987. (Courtesy of WSU.)

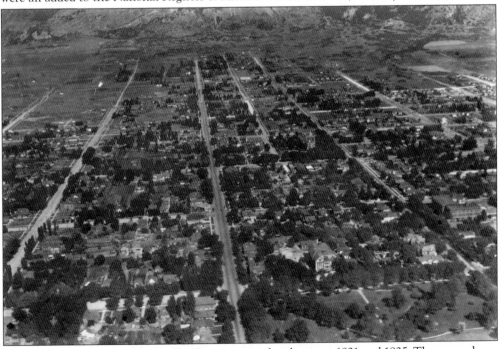

This aerial photograph of the Trolley District was taken between 1921 and 1925. The scene shows the correlation between development and the trolley lines on Twenty-third and Twenty-fifth Streets. The central street is Twenty-fourth Street, and Lester Park is at lower right. Eccles Circle and streetcars on the lines running through the district are also seen. (Courtesy of WSU.)

The White City Ballroom, opened by Harman Peery in 1922, was once located on the 2400–2500 block between Washington Boulevard and Adams Avenue. The venue was popular for big band dances, large gatherings, and elaborate dinners. It could seat thousands and even hosted Duke Ellington and his orchestra on May 6, 1940, in one of his few Utah appearances. (Courtesy of WSU.)

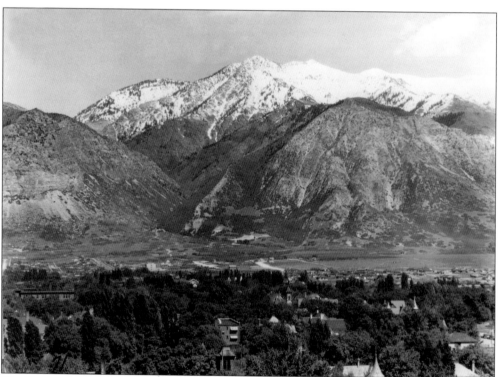

The Trolley District essentially ends at Harrison Boulevard. When this 1920s aerial photograph was taken, Harrison was just another east-west street, but it was widened around 1960. In the image, the majority of the bench land was still rural but the mountain seems so familiar. Snow-capped Mount Ogden looks over the Trolley District, and the mouth of Taylor Canyon is still heavily hiked today. (Courtesy of WSU.)

Four

TROLLEY DISTRICT ARCHITECTURE

The Trolley District today is formally recognized as the Ogden Central Bench National Historic District. The area boasts a convenient location directly adjacent to the downtown central business district. Ogden's population explosion following the coming of the railroad in 1869 necessitated the development of the first bench as Ogden's primary residential neighborhood.

Then and now, a unique feature of the area is its economic diversity. Millionaires and the middle class live side-by-side with the working families. Mansions, cottages, and apartment complexes were built adjacent to each other, commingling with churches, schools, and mercantile buildings. This physical and socioeconomic blending still occurs today, making the neighborhood interesting and diverse. The historic streetscapes, pedestrian-scaled buildings, and architectural elements such as front porches all facilitate neighbor interaction, enhancing the area's sense of community.

Prior to the railroad era, the architecture of Ogden had a distinctive regional look—a simple and practical style that was primarily focused on survival in the rugged west. The railroad brought civilization, goods, building supplies, and national style, which instantly began to influence the city's architecture. Beginning with Victorian excess, the district became home to some of the best examples of national architectural movements. Many architects started their careers in Ogden, including Leslie S. Hodgson, Myrl A. McClenahan, Moroni Charles Woods, Art Shreeve, Samuel T. Whitaker, and Eber Piers, to name a few.

Over the years, the Trolley District became layered with subsequent architectural styles including Neoclassical, Arts & Crafts, Art Deco, and numerous revival styles. In terms of the landscape of the neighborhood, styles generally transition from west to east following the progression of development over time. Still, there are many examples of infill and redevelopment of older structures with newer styles. The resulting effect was a rich visual and tactile palette of space, form, and materiality that is largely intact to this day.

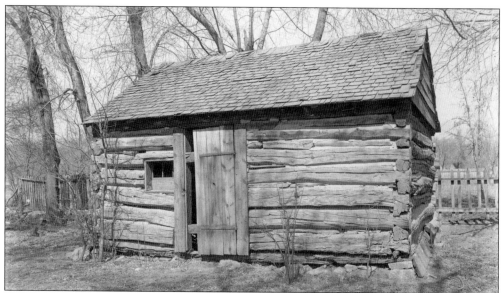

The Miles Goodyear cabin is the oldest building in Ogden, constructed in 1845 as part of a complex of buildings comprising Fort Buenaventura. While the log cabin was technically constructed outside of the Trolley District, it represents the earliest non-native vernacular common in Ogden and Utah. Miles Goodyear was a trapper and fur trader who had explored and lived in the Rocky Mountain region since the age of 19. He eventually settled in the area, selecting the site for Fort Buenaventura based on its scenic and practical location adjacent to the Ogden and Weber Rivers, with abundant fertile land. Mormon pioneers soon followed suit. Below is a rustic pioneer dwelling on Twenty-eighth Street. (Above, courtesy of WSU; below, courtesy of Union Station.)

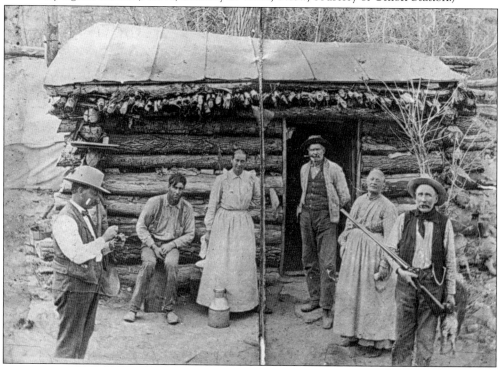

This unidentified pioneer-era home in the Ogden area illustrates the typical single-story hall-parlor vernacular. This house is made of brick, with two chimneys at both gable ends of the structure. The simple construction and native landscape typify the early settlers' focus on survival in the rugged Utah landscape. (Courtesy of WSU.)

This later image looks as if it could be the same home as the one above, a coincidence exemplifying the commonality of this early architectural style. A few remnant pioneer homes can still be found in Ogden and the Trolley District, although many have been altered or added onto over the years. (Courtesy of WSU.)

This early pioneer residence appears to have a second story or additional half-story. Note the rural landscape with a simple wooden picket fence and hay barn. This rural scene would dramatically change within a decade of the railroad coming to Ogden in 1869. (Courtesy of WSU.)

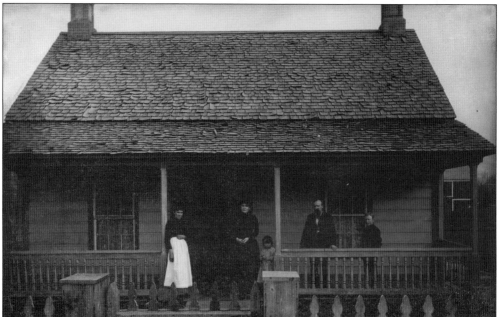

This early Ogden family poses on the front porch of their pioneer-era home. Porches provided a semi-private transition space to the homes of this era, while also serving as a sort of sunscreen, providing shade and limited climate control. (Courtesy of WSU.)

These two images illustrate the early Victorian adaptations to the pioneer style—a cross-wing house. The L-shape of the floor plan includes a front porch and prominent front gable. The home pictured below features decorative woodwork. Its ornamentation is an early precedent to the flamboyance of the elaborate mansions of the Victorian-era Trolley District. (Courtesy of WSU.)

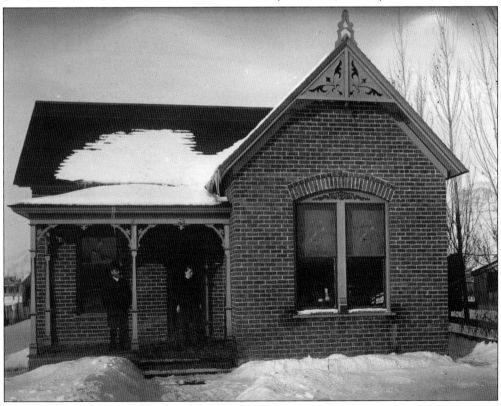

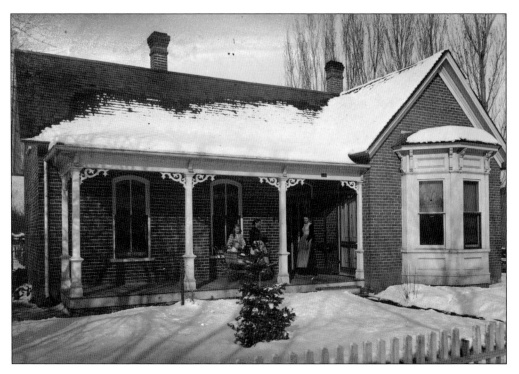

As the country became increasingly connected through the railroad, the architectural styles of Ogden began to follow national trends. These storybook adaptations of cross-wing plans exemplify the picturesque styles often seen in architectural pattern books. The Ray Becraft home is above, while the house below is unidentified. (Courtesy of WSU.)

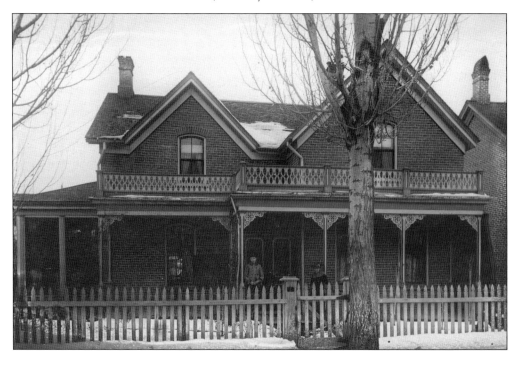

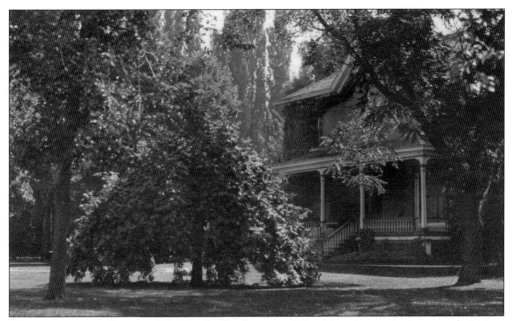

The picturesque style extended into the landscape, as Victorians increasingly spent their time beautifying their yards and neighborhoods. The idea of living in a park was typified by large grassy lawn areas, ornamental shade trees, and mixed perennial border plantings. During this era, greenhouses and atriums also became popular, extending the growing season for annual plants and increasing their use in the landscape in what were termed "carpet beds." (Courtesy of WSU.)

The Belnap home, at 2149 Madison Avenue, is a picturesque-style structure with a beautiful landscape. The Belnaps are among the earliest Ogden families, dating back to when Ogden was settled by Mormon pioneers. Gilbert Belnap was one of the first settlers and later became a county commissioner. Hyrum Belnap, his son, served as a Weber County assessor. (Courtesy of WSU.)

As the residents of the Trolley District became more affluent, juxtapositions like this became increasingly common. Eventually, many of the pre–railroad era homes were replaced by more popular and spacious Victorian residences. The neighborhood still has an eclectic mix of various historic structures. (Courtesy of WSU.)

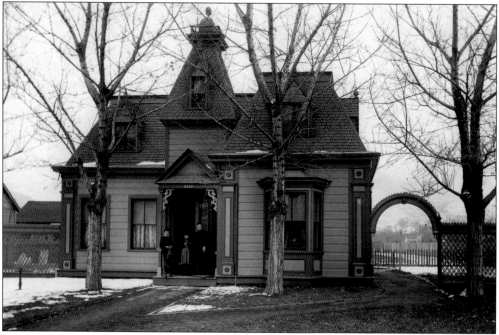

Despite the extreme growth and development of the late 1800s, most of the residential areas outside downtown continued to maintain a rural feel. It wasn't until the streetcar made large portions of the bench accessible that it was developed. (Courtesy of WSU.)

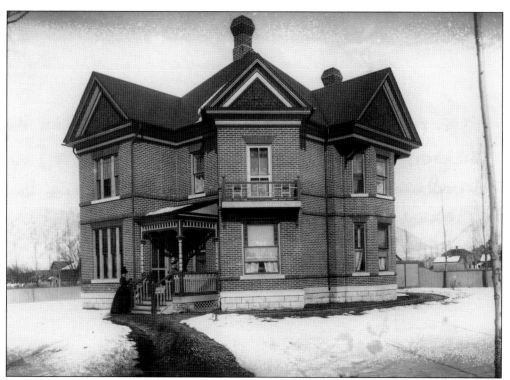

The Sidney Stevens residence stood alone, a stately three-gable Victorian with spacious grounds. Few other structures were in the immediate vicinity of the house. Today, the home still stands, but it is surrounded by many houses built in the early 20th century. (Courtesy of WSU.)

Samual T. Whitaker was another Trolley District resident with ties to the development of the Trolley District homes. He was the architect who designed the home for John Armstrong (now the Eccles Art Center) and the home for John M. Browning located at 505 Twenty-seventh Street. Whitaker also replaced accused murderer Peter Mortensen in the design of the historic Forest Dale ward house in Salt Lake City. Mortensen allegedly killed the treasurer of a lumber company to which he owed funds for the early construction of the building, and Whitaker won the competition to replace him as architect on the project. (Courtesy of WSU.)

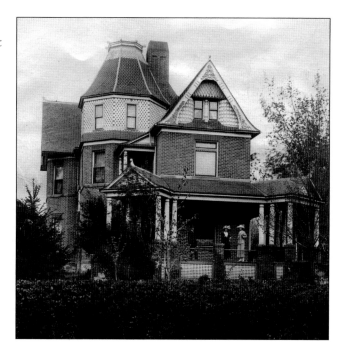

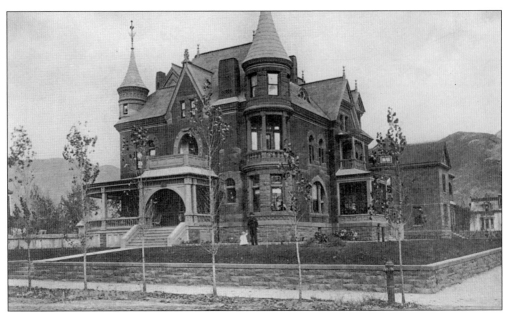

The Eccles Mansion was built in 1893 for Ogden businessman James Clarence Armstrong and was designed by Samuel Whitaker. The structure is one of the most elaborate Victorian mansions remaining in Ogden today, and is preserved as the home of the Eccles Community Art Center. The architectural styling of this building is most commonly described as Queen Anne, but probably falls more into the Chateauesque style because of its sandstone construction and detailing. (Courtesy of Union Station.)

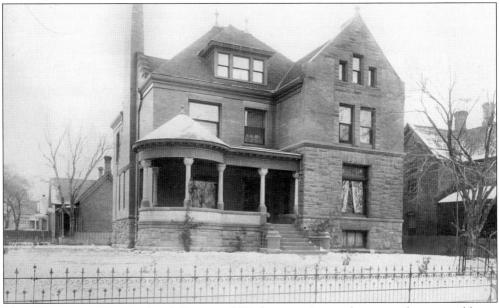

This mansion near Twenty-fourth Street and Washington Avenue bears a striking resemblance to John M. Browning's home at 505 Twenty-seventh Street, possibly because it was designed by the same architect, Samuel T. Whitaker. This home was owned by Mariner S. Browning, the nephew of John M. Browning. Mariner became one of the founding owners of the First Security Bank. (Courtesy of Union Station.)

This lovely Victorian home was likely located on the 2400 block of Monroe Boulevard, on the east side of the street. The home is no longer intact, but is reminiscent of many similar Victorian structures of the same era. The massing is reminiscent of a Queen Anne style, but the structure is smaller and more simply decorated with an Eastlake motif. (Courtesy of WSU.)

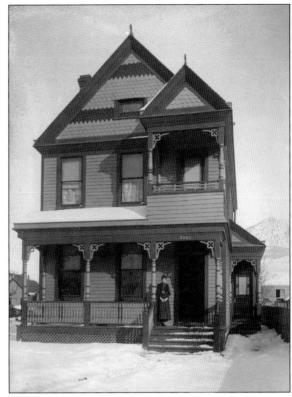

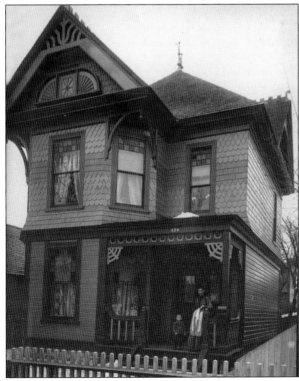

This house, lost years ago, was an interesting example of the Gothic influence in Victorian architecture. The woodwork is quite intricate, as are the spider-web brackets on the front porch, the iron finial, and decorative metal ridge cap, all indicative of the Gothic revival influence. (Courtesy of WSU.)

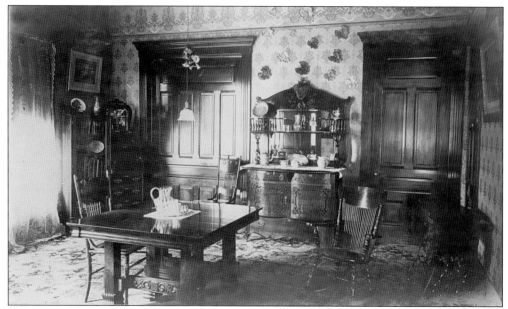

The interiors of the Victorian homes in the Trolley District were often just as elaborate as the exterior. Shown here is the dining room of the O.A. Parmley residence at 730 Twenty-fifth Street, which has undergone an amazing restoration. The dining room remains an active part of the home. (Courtesy of Union Station.)

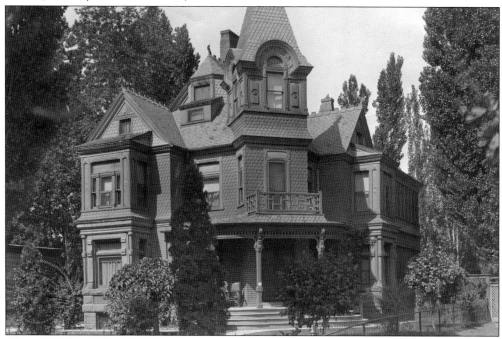

The original Patrick Healy Mansion at 2529 Jefferson Avenue is a classic example of the high-Victorian era. The asymmetrical massing, turret, multiple gables, and nearly 6,000 square feet of living space represent the pinnacle of architectural excess, typical for the Trolley District in the late 1800s. This home has recently been converted back to a single-family residence, after spending decades as a seven-plex boarding house. (Courtesy of WSU.)

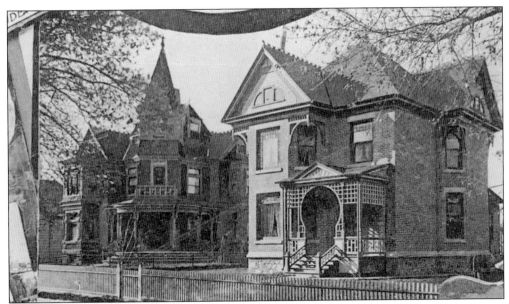

The two houses above, at 2523 and 2529 Jefferson Avenue, were built by Edmund Hulaniski and William V. Helfrich, respectively. Helfrich, the Ogden treasurer, was caught for embezzlement, and the home was bought in foreclosure by Patrick Healy. Below is the Don Maguire residence at 549 Twenty-fifth Street. These two images, enlarged from Victorian era postcards, highlight the idealized view of civilized Victorian neighborhoods. Notice the low fences that have become more delicate and refined, the massing and detailing on the houses, and civilized elements like front porches. (Courtesy of Union Station.)

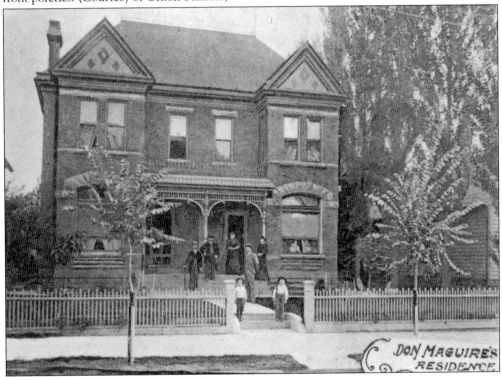

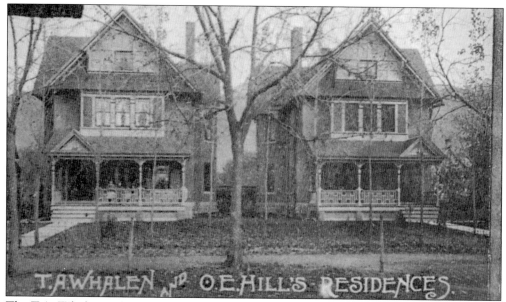

The T.A. Whalen and O.E. Hill residences at 2532 and 2540 Jefferson Avenue are seen in this enlarged postcard. The houses, known as the twin homes in the 2500 block of Jefferson Avenue, exhibit the pattern styles builders would often utilize in the Victorian era's version of mass production. The two homes, built along the Jefferson Street line, are nearly identical, mirror-reverse floor plans, which coexist today as single-family homes, both recently restored. (Courtesy of Union Station.)

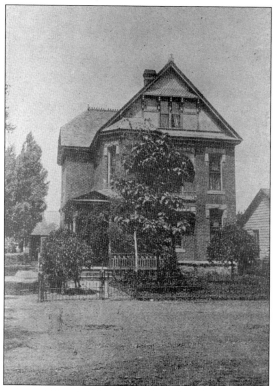

The C.A. Smarthwaite residence was located on Jefferson Avenue, along the west side of the street between Twenty-third and Twenty-fourth Streets. Although split up in the 1940s into multifamily apartments, the home still stands today, complete with much of the original trim. Evidence has been discovered showing that this block of Jefferson was at one time a part of the streetcar system. (Courtesy of Union Station.)

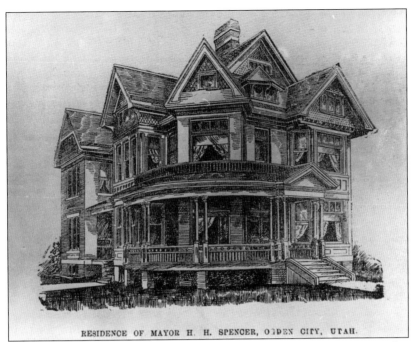

RESIDENCE OF MAYOR H. H. SPENCER, OGDEN CITY, UTAH.

The changes made to the Spencer-Eccles home highlight changing architectural tastes over the years. The original Queen Anne Victorian illustrated above was built for Mayor Hyrum H. Spencer in 1895. The residence was later owned by William H. and Mary Eccles, who replaced the front porch with the southern colonial Greek revival style portico seen in this 1914 image, after traveling to the southern states. (Above, courtesy of WSU; below, courtesy of Union Station.)

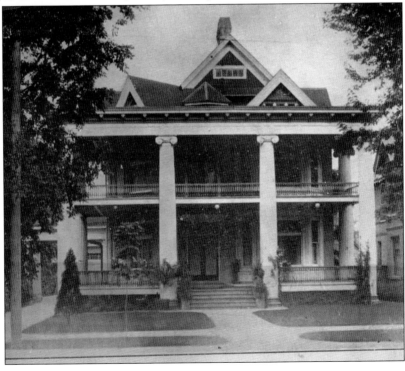

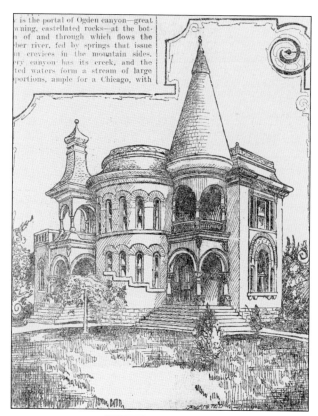

It was not uncommon to see drawings of homes published in the local papers rather than photographs, as shown in the illustration at left for the Dennis Smyth home in 1889. A Victorian Eclectic structure, this home was designed by Samuel T. Whitaker for Smyth, an Irish immigrant who worked for the Union Pacific Railroad. This home still exists today on the corner of Twenty-fifth Street and Orchard Avenue. The image below shows the home when it was lived in by Fred M. Nye. (Both, courtesy of Union Station.)

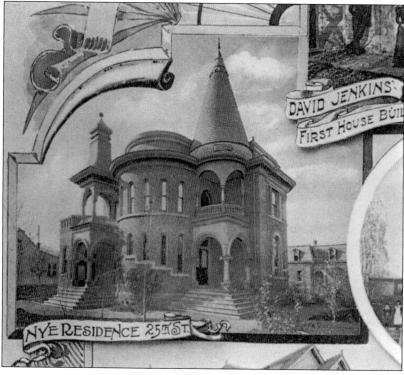

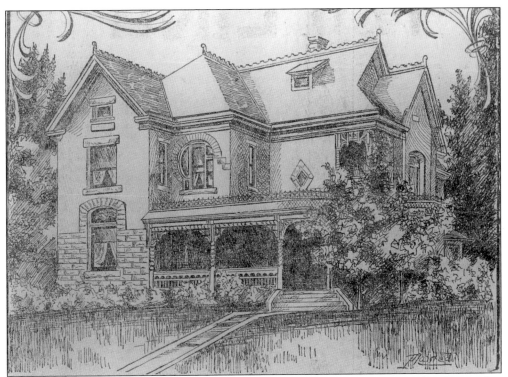

The above image illustrates the house of then-councilman William Driver, and is dated December 20, 1902. The 1914 image below shows the home with mature landscaping and an active social presence. (Both, courtesy of Union Station.)

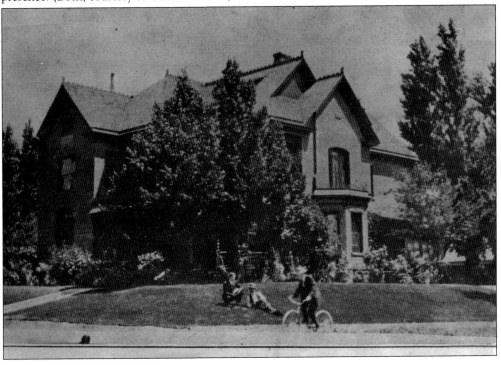

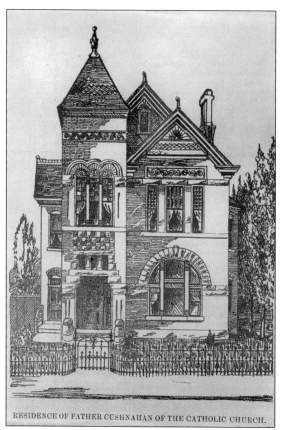

RESIDENCE OF FATHER CUSHNAHAN OF THE CATHOLIC CHURCH.

This detailed illustration depicts the Victorian Romanesque Revival residence of Father Patrick Cushnahan on January 1, 1897. Father Cushnahan was a driving force in the development of Catholicism in Ogden. On April 14, 1908, a burglary targeted the residence and Father Cushnahan lost some valuable silver, gifts from parishioners throughout Utah. (Courtesy of Union Station.)

The Victorian foursquare-style J.L. Reynolds residence is seen in 1906. It demonstrates the early transition, with a trend toward simplification, to the Arts & Crafts era. This home has survived at 2533 Adams Avenue, but is now a five-plex that has been stripped of its front porch, side appurtenances, and back porch. (Courtesy of Union Station.)

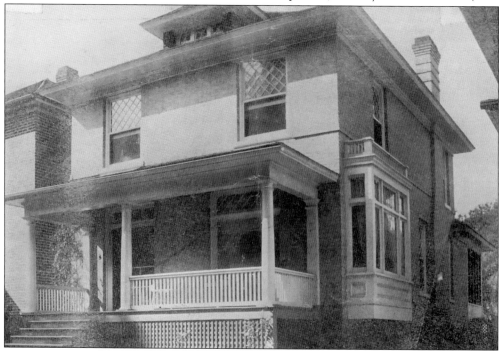

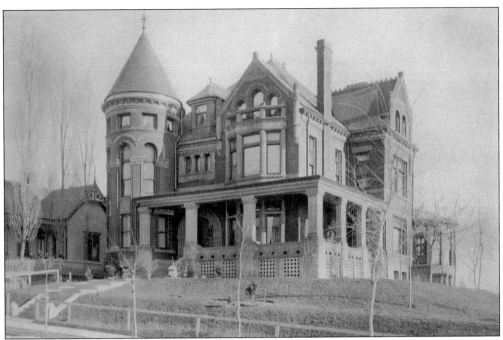

These two images of the John Scowcroft Mansion on Twenty-sixth Street illustrate the changing look of the neighborhood over time. The above image shows an adjacent Victorian-era cottage, while the image below includes a significantly larger foursquare home next to the famed mansion. The foursquare house (left), at 541 Twenty-sixth Street, is still standing today and has undergone renovation, with its detailed original interior woodwork still intact. (Both, courtesy of Union Station.)

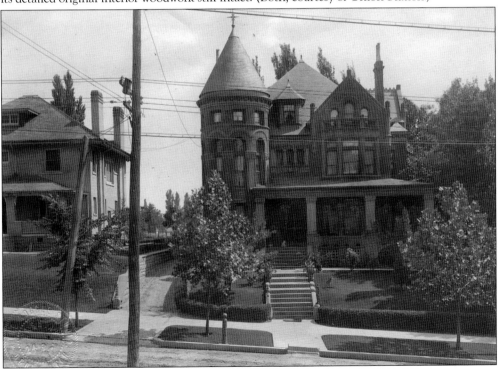

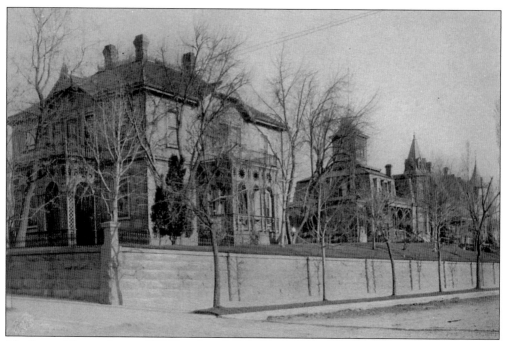

The Second Empire home of F.J. Keisel on the southeast corner of Twenty-fifth Street and Adams Avenue exemplifies Victorian style. The Victorians frequently used retaining walls to create terraces in the landscape. These walls are still apparent throughout the Trolley District today, outliving many of the homes they surrounded. (Courtesy of Union Station.)

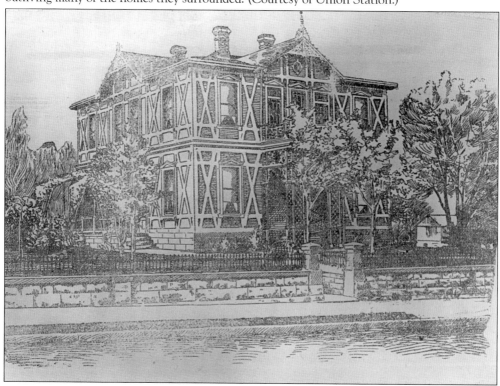

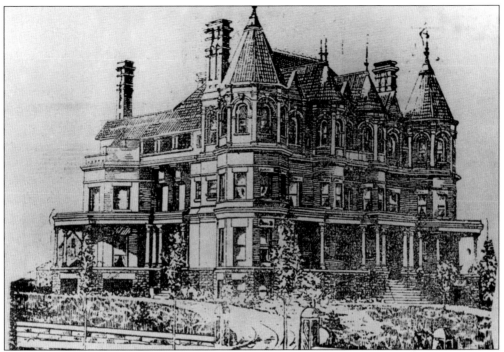

This illustration and photograph show the David Peery residence on the corner of Adams Avenue and Twenty-fourth Street, named "Virginia" after his home state. This Victorian chateau was perhaps one of the most elaborate mansions of the Trolley District, with its substantial masonry form, round corner turrets, conical roofs, and classical detailing. (Above, courtesy of Union Station; below, courtesy of WSU.)

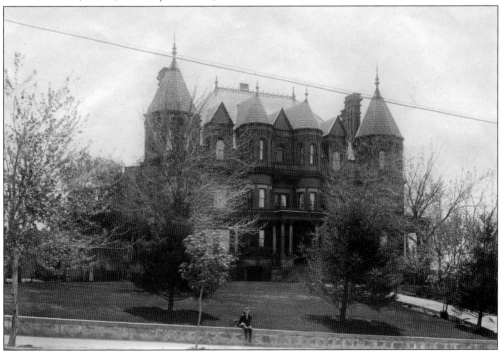

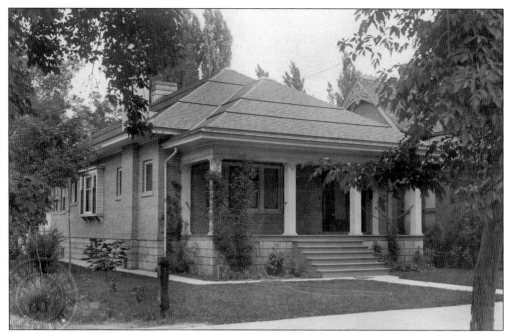

Architect Leslie S. Hodgson was extremely prolific, designing not only the most prominent public and commercial structures in Ogden, but also dozens of private residential structures. The Douglas home (above) and the Fred Nye home (below) are both variations on the classic American bungalow. The Nye home is one of the few untouched by the carpenter's hammer and remains a single-family home today. (Both, courtesy of WSU.)

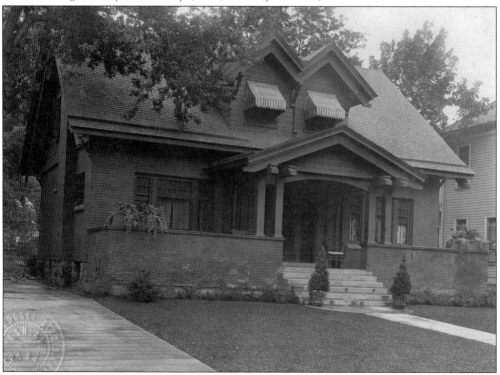

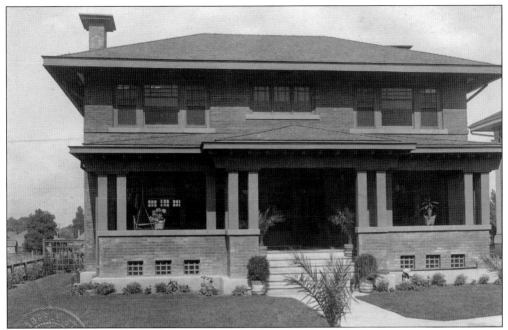

This Prairie style home at 2522 Eccles Avenue features intricate brick detailing around the upper frieze borders and double pillars supporting a spacious front porch. This home spent many years as a state-run girls' home and has recently been restored. Amazingly, its architectural charm was only slightly compromised during state ownership. (Courtesy of WSU.)

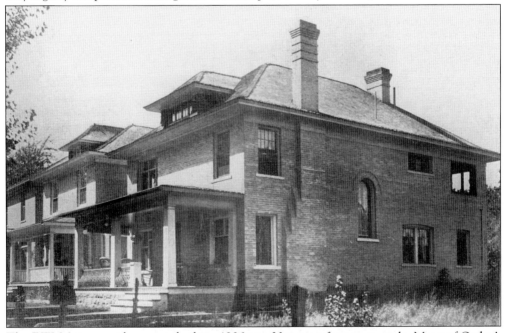

The E.W. Matson residence was built in 1906 in a Victorian foursquare style. Many of Ogden's foursquare and Prairie homes were constructed around that time. Matson was one of the founding partners of the Utah Canning Company (founded in 1897), along with Thomas Dee, Isaac N. Pierce, George H Matson, and James Taylor. (Courtesy of Union Station.)

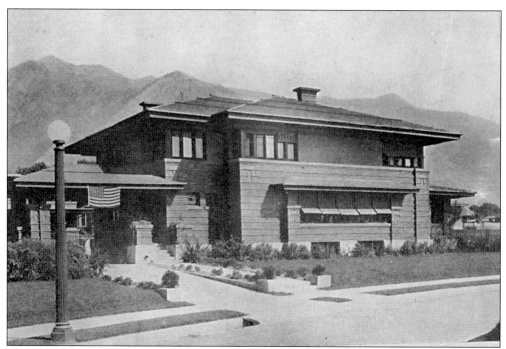

The 1914 Edmund O. Wattis House was designed by Eber Piers. The Prairie style architecture is defined by the large overhangs, horizontal brick, and the lines of the porte-cochere and sun porch extending into the landscape. It is one of the best examples of Prairie architecture in the area, and also one of the best preserved, having been recently restored by Wattis's grandchildren in 2004–2006. (Courtesy of WSU.)

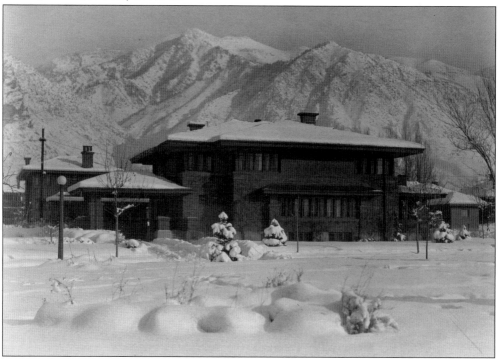

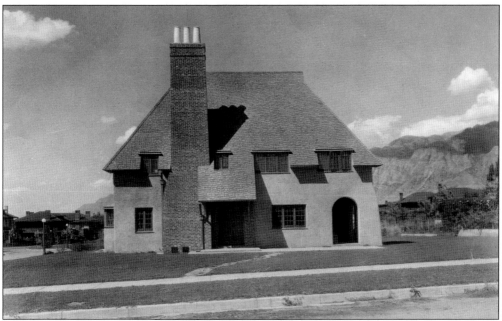

Built for Patrick Healy Jr. and his wife, Mary, this Tudor-revival mansion at 2580 Eccles Avenue stands apart from the other architectural styles of the Eccles District. (Courtesy of WSU.)

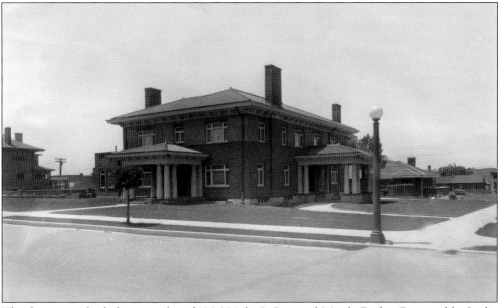

This home was built for more than $100,000 for LeRoy and Myrtle Eccles. Designed by Leslie Hodgson, the home is in the Italian Renaissance style. The imported Italian wood staircase, a peerless art nouveau window on the landing, elegant stained glass windows, Tuscan columns, and red clay tile roof have survived through the various owners of the mansion. LeRoy Eccles was vice president and general manager of the Amalgamated Sugar Company, and was also involved with the Ogden, Logan & Idaho Railroad. The Eccles home has transitioned through many parts of Ogden's colorful history, serving time as the infamous Weber Club; currently, it is the Ivy Lane Reception Center. (Courtesy of WSU.)

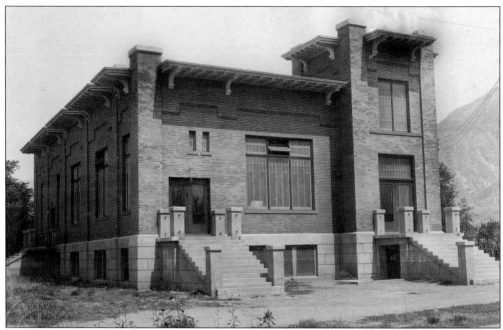

This Prairie style structure is an unidentified work of architect Leslie Hodgson. The profile of the mountain in the background places it in or near the Trolley District. The building has beautiful Prairie style lines. Based on the massing of the tower above the entry and the formality of the windows and doors, it was most likely used as an institutional or religious building. (Courtesy of WSU.)

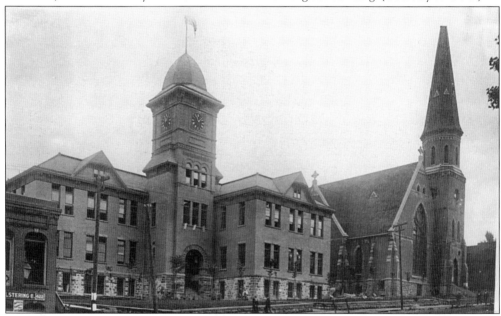

This photograph of the Weber County Courthouse and First Methodist Episcopal Church shows the scale of the Victorian and Gothic Romanesque building at the periphery of the Trolley District on Twenty-fouth Street. Both structures featured rock-faced foundations, substantial masonry walls, and towers. Sadly, neither building exists today, replaced by the wave of progress that worked its way through Ogden in the early 20th century. (Courtesy of Union Station.)

St. Paul's German Evangelical Church, originally built as the Swedish Evangelical Lutheran Church at 580 Twenty-third Street, is a subdued structure with some Victorian Romanesque Revival design elements like masonry walls with semicircular arches on the windows, polychrome masonry, and a tower. It is eclectic in its overall styling, with details like shingle siding in the right gable. The church was purchased by the Japanese Christian Church in 1929 and still stands today, mostly intact, at the corner of Twenty-third Street and Jefferson Avenue. (Courtesy of WSU.)

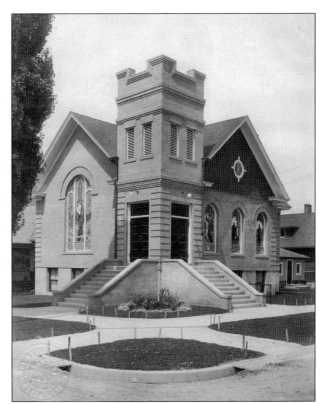

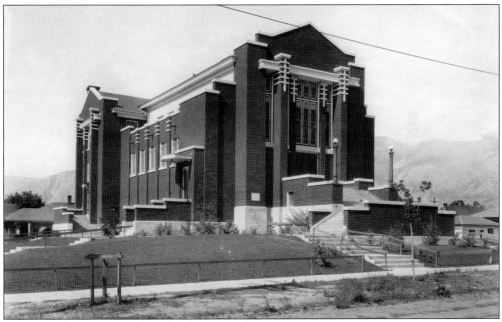

This amazing church structure at Twenty-third Street and Jackson Avenue has dominant Prairie style elements reminiscent of Frank Lloyd Wright's design for the Unity Temple in Chicago. It is still being used as a church, its detailed Prairie trim still evident and well preserved. (Courtesy of WSU.)

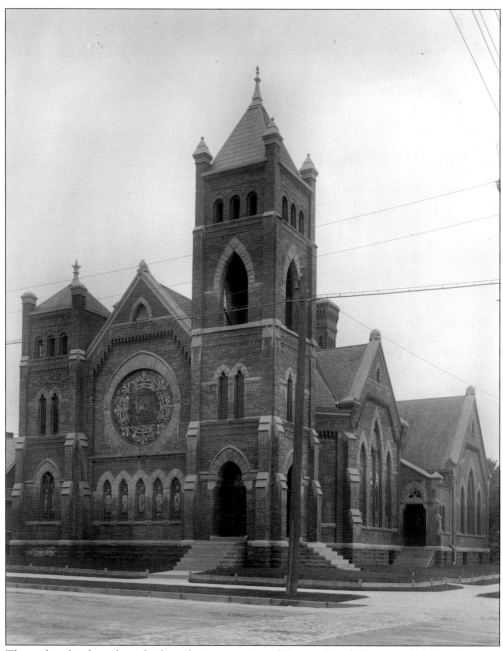

Three churches have been built at the intersection of Twenty-fourth Street and Adams Avenue. Two of them, the First Presbyterian Church (pictured) and Saint Joseph's Cathedral (opposite) still stand today. First Presbyterian has been converted to a bar with an altered structure and bricked-in windows.

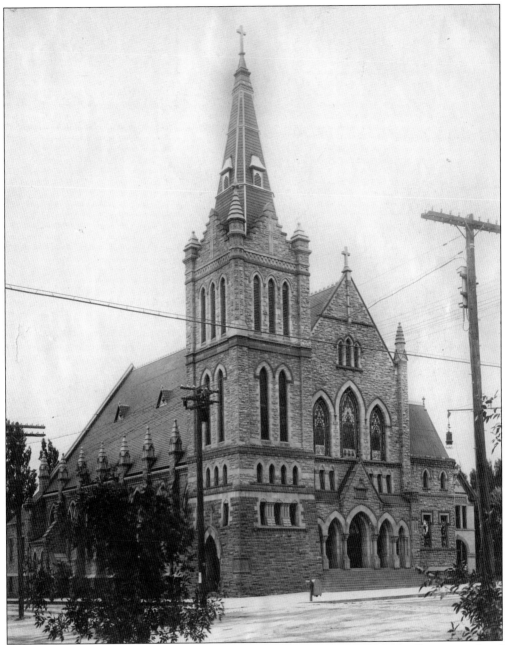

Both First Presbyterian Church and Saint Joseph's Cathedral (pictured) are excellent examples of Victorian Gothic churches. The third church built at this intersection, the Methodist Episcopal Church, was razed years ago. (Courtesy of WSU.)

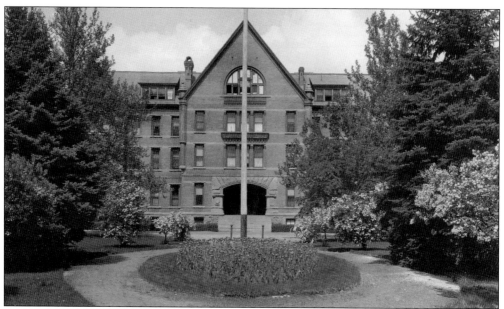

Ogden's first bond election to build schools was held in March 1891. The proceeds of two bond issues erected the Madison school—for $33,000—along with eight others. These nine schools marked the introduction of the public school system in Ogden and Utah. The Romanesque Revival style building is the oldest school building still standing in Ogden. The school has since been converted to apartments and now borders the Oasis Community Garden, a current project of the Junior League of Ogden. The building is on the local, state, and national historic registers. (Courtesy of WSU.)

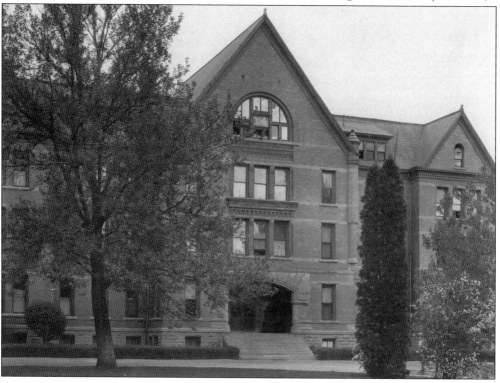

The Sacred Heart Academy opened in 1892 at the northeast corner of Twenty-fifth Street and Quincy Avenue. The land for the Catholic school was purchased in 1881 from M.H. Wheelwright for $20,000. The architect was Francis C. Woods, and John Collins was the contractor for this Victorian eclectic structure. Note the streetcar tracks visible in the road in the foreground. The school operated until June 1938. (Courtesy of WSU.)

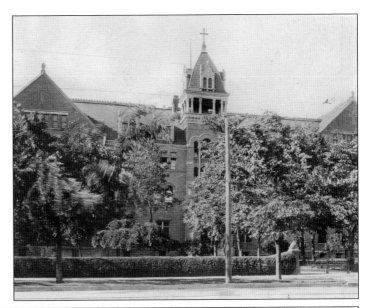

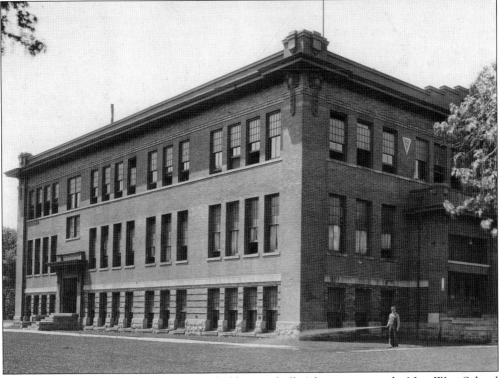

In 1890, Ogden High School classes were held at city hall. After moving to the New West School in 1896, enrollment continued to increase. The original Ogden High School building, at Twenty-fifth Street and Monroe Boulevard, was built on land donated by Fred J. Kiesel. At a cost of $100,000, Leslie S. Hodgson and the Eccles Lumber Company built the new school, which was converted to Central Junior High when a new high school on Harrison Boulevard was completed in 1936. Today, Madison Elementary School sits on the site, which is at the geographic center of the Trolley District. (Courtesy of WSU.)

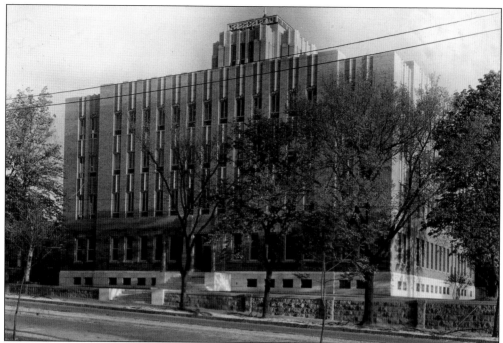

The US Forest Service building, at Twenty-fifth Street and Adams Avenue, was built in 1933 and designed by the firm of Hodgson and McClenahan. Ogden was originally selected as the district headquarters for the agency in 1908 because of the city's railroad prominence. Today, the building houses the Region No. 4 headquarters, overseeing operations in Arizona, Colorado, Idaho, Montana, Nevada, New Mexico, Utah, and Wyoming. (Courtesy of Union Station.)

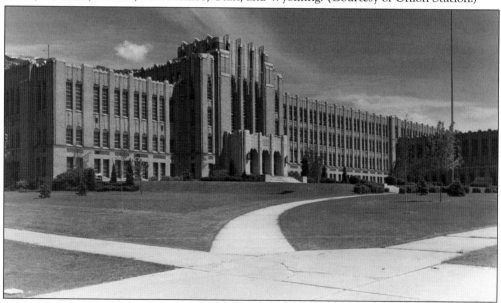

Designed by the firm of Hodgson and McClenahan and built in 1937 as part of the Public Works Act, the Ogden High School still stands as one of Utah's best examples of Art Deco architecture. The building demarcates the east end of the Trolley District at Harrison Boulevard. The high school has undergone extensive renovation. (Courtesy of WSU.)

Five

BUILDERS OF THE TROLLEY DISTRICT AND THE NATION

The legacies of several prominent citizens of the Trolley District and Ogden are well represented throughout the community today. Eccles, Browning, Kiesel, Wattis, and Scowcroft are all familiar names gracing today's landmarks. These people were not only prolific in their business endeavors, but also in their generosity and service to the community. They were not merely a collection of individuals, but rather a close-knit community with frequent interactions, business dealings, and social events making for fascinating and relatable stories. These prominent citizens built their homes in proximity to the streetcar for its ease of access to their downtown business activities.

While there are a number of individuals featured in this chapter, one particularly significant person was David Eccles, the founder of the Ogden Rapid Transit Company (1900–1947). In addition to managing the expansion and operations of Ogden's extensive urban railway system, Eccles was recognized as one of the wealthiest individuals in northern Utah. He sprang from humble beginnings in relative poverty in Scotland, working his way to become one of Utah's first multi-millionaires. The streetcar built the Trolley District, and David Eccles built the streetcar.

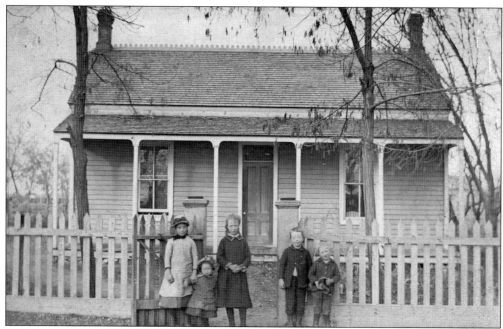

This simple pioneer-era cottage was owned by George Kerr. He was Union Depot's first depot master, holding the position from 1889 to 1904, and a familiar sight around town. (Courtesy of WSU.)

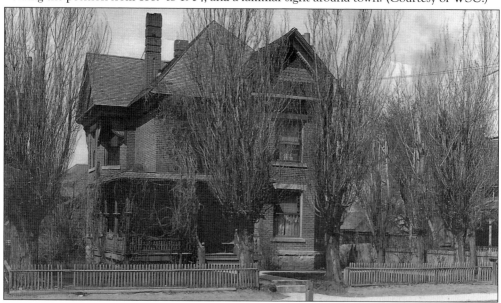

Thomas Jordan Stevens was one of Ogden's prominent banking leaders, serving as executive vice president of Utah Loan and Trust Company, city commissioner, and one-time Weber County sheriff. He built his home at 2575 Jefferson Avenue. Several executives of Commercial National Bank also made Jefferson Avenue their home. The first was Thomas Whalen, who lived at 2532 Jefferson and was a member of the bank's executive committee and a city council member. Three vice presidents later joined Whalen in the Jefferson area: Patrick Healy, at 2529 Jefferson; Ogden mayor Abbott R. Heywood, at 2540 Jefferson; and Isadore Marks, one of the first non-Mormon occupants of the street, at 2547 Jefferson. (Courtesy of Rae Mildenhall.)

David Eccles emigrated from Scotland, and his wife, Bertha Jensen Eccles, came from Denmark. Coming together in Ogden, they gave the city the gifts of business development and volunteerism. Bertha Eccles was instrumental in encouraging the early meetings of the Girl Scouts, the Children's Aid Society, the Martha Society, the Daughters of Utah Pioneers, the Red Cross, the Drama Club, and the Child Culture during the 50 years she lived here. The Girl Scouts celebrated their 100th anniversary at the mansion in March 2012. (Courtesy of WSU.)

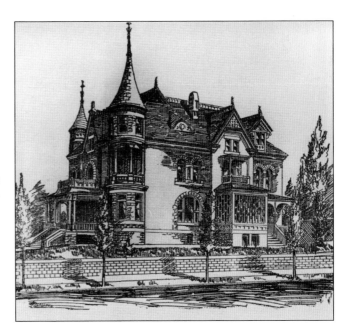

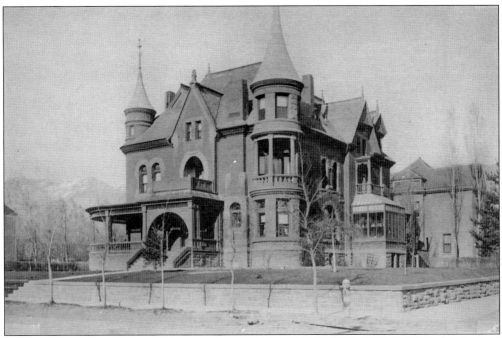

Three years after it was built for Ogden businessman James Clarence Armstrong, this Samuel Whitaker–designed mansion became the Eccles mansion when David and Bertha Eccles moved into it in 1896 and raised their 12 children there. A Prairie style carriage house and a sun porch were added in 1913. The mansion was donated to Weber College in 1948 and used as a dormitory before being deeded to the Ogden Arts Council to become a community art center in 1959. (Courtesy of Union Station.)

In 1906, the Ogden Charitable Committee met for the first time, convened by Martha Brown Cannon, the wife of Utah's first senator, Frank J. Cannon. When Martha Cannon died in 1908, the committee was renamed the Martha Society. In 1934, Dolores Eccles spearheaded the formation of the Welfare League of Ogden. Together, these two entities merged to create the Junior League of Ogden in 1953. The Junior League's contribution to the Trolley District and the overall welfare of the community was vast and continues today, and it still meets in the mansion. (Courtesy of WSU.)

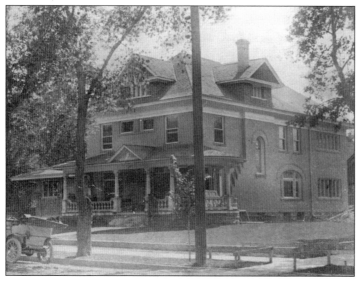

Built in 1907 for David C. Eccles, the son of David Eccles, this home was designed by Smith & Hodgson. David C. Eccles lived there until 1919, when he relocated to Portland. He was the president of the Utah National Bank of Ogden, now Wells Fargo. The house transitioned through many stages of Ogden history, becoming a real estate office and a multifamily residence before being restored to much of its former glory. (Courtesy of Union Station.)

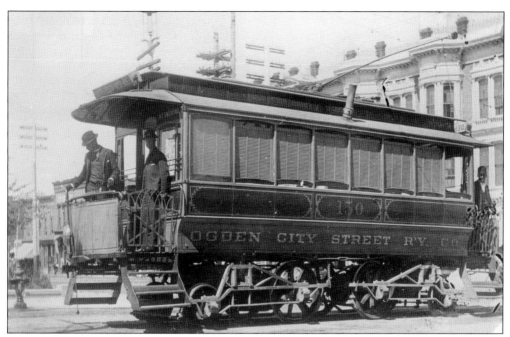

John M. and Matthew S. Browning are seen here riding the streetcar at Twenty-fifth Street and Washington Boulevard. John M. Browning's home was at 505 Twenty-seventh Street and the trolley was the most convenient way to get to his gun shops on Kiesel Avenue and Washington Boulevard. This photograph may have been one of the last taken aboard an Ogden City Street Railway car, as the ownership changed in May 1900. (Courtesy of Union Station.)

In 1899, Thomas Dee and David Eccles purchased the deteriorated street railway system from its Midwestern owners, Jarvis-Conklin, organizing Ogden Rapid Transit Company (ORT) in May 1900. Over the years, ORT transformed the ragtag system into expansive miles of track, including a line to Ogden Canyon. Dee Memorial Hospital was named after him by his wife, Annie Taylor Dee, who hoped for increased quality healthcare in Ogden. (Courtesy of WSU.)

John Moses Browning, born in Ogden in January 1855, is recognized even today as the one of the most influential firearms designers ever. He invented many varieties of firearms, cartridges, and gun mechanisms, many of which are still in use today worldwide. He made his first firearm at age 13 in his father Jonathon Browning's gun shop, and was awarded his first patent at 24. He lived to be 71, leaving behind a lasting legacy of firearms. (Courtesy of WSU.)

Val Allen Browning, born in 1895, carried on the family gun business. Known in Ogden as a generous philanthropist, Val worked in the shop his grandfather Jonathan Browning opened. Once his father, John M. Browning, vacated the home at 505 Twenty-seventh Street, Val lived there for a bit before the home was sold to the YWCA. He lived to the ripe age of 98, witnessing many of Ogden's changes over time. (Courtesy of WSU.)

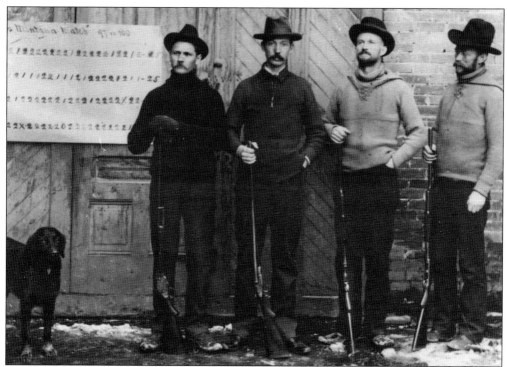

The famous "4-B" shooting team of, from left to right, Becker, Bigelow, Browning, and Browning is seen here. Gustaf Lorenz "G.L." Becker was especially known for his prowess in marksmanship, winning numerous competitions. The local papers were often filled with articles praising the victorious Becker. (Courtesy of WSU.)

The amazing home of G.L. Becker still stands at the corner of Twenty-fourth Street and Van Buren Avenue. Becker was born in Winona, Minnesota, in 1868 to John S. and Katherine Becker, staying there through his college years at Lambert College. In 1890, he arrived in Ogden to be placed in charge of his father's brewery. In 1891, he and his brother took over for the elder Becker and changed the name from Schellhas Brewing Company to Becker Brewing & Malting Company. (Courtesy of WSU.)

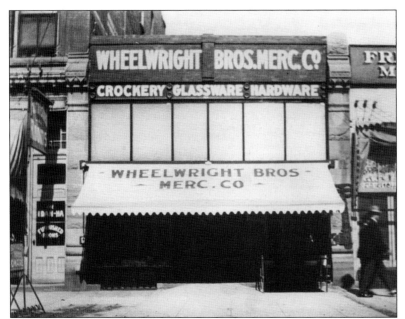

The Wheelwright families lived on Jackson Avenue in the Trolley District. They moved their business from 2476 Washington Boulevard to 2461 Quincy Avenue, where they provided lumber and building materials for many of the homes in the district, and still do from their new location on Midland Drive. (Courtesy of WSU.)

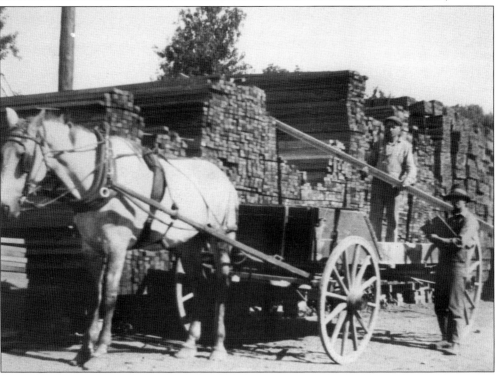

The Wheelwright Brothers Mercantile Co. was originally founded in 1890 by Thomas B. and George M. Wheelwright as a secondhand store. In 1894, the mercantile expanded to include groceries and hardware. In 1907, a sawmill was built between Twenty-fourth and Twenty-fifth Streets on Quincy Avenue, still on the outskirts of town at the time. Before long, the demand for precut lumber exceeded the production ability of the mill. In 1908, the name of Wheelwright Lumber Co. was officially adopted. (Courtesy of WSU.)

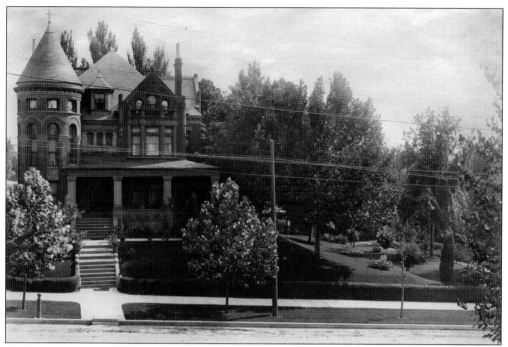

This home, once located at 533 Twenty-sixth Street, was fondly called "Lancaster" after the county seat of owner John Scowcroft's original home in Tottington, Lancashire, England. Scowcroft and his wife, Mary, were some of the first Ogden pioneers, settling in 1880. After learning the confectionary business in England, he took those skills and started in business in Ogden, soon transitioning to dry goods. He founded John Scowcroft & Sons Wholesale Dry Goods in 1881. The business boomed and was managed by his wife and sons after his death in 1900. (Courtesy of WSU.)

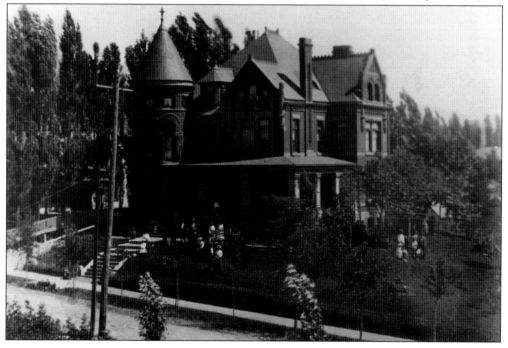

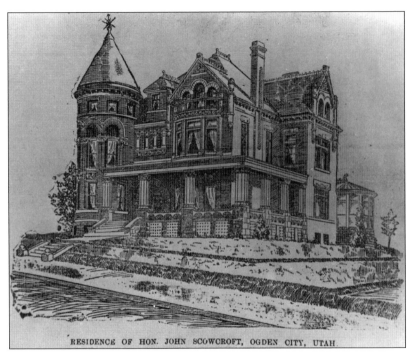

RESIDENCE OF HON. JOHN SCOWCROFT, OGDEN CITY, UTAH.

These two drawings illustrate contrasting perspectives of the "Lancaster." Many prints were done in this style featuring the homes of prominent members of the community. The masculine perspective, above, reflects the strong lines of the home. The feminine rendering for Mary Scowcroft, below, is far more scenic, showing extensive landscape embellishments. Mary Scowcroft was a wonderful philanthropist who was encouraged by her husband, as the success of Scowcroft Enterprises continued to build Ogden. (Above, courtesy of WSU; below, courtesy of Union Station.)

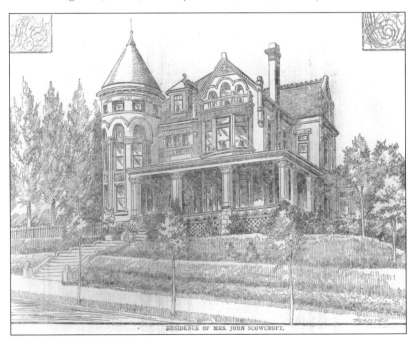

RESIDENCE OF MRS. JOHN SCOWCROFT.

In 1889, Fred J. Kiesel was elected the first non-Mormon mayor in Ogden, and the headline in the *Utah Daily Union* read, "Ogden Americanized." Kiesel was a character, contributing much to the development of Ogden, not only in the physical sense, but as a community member as well. At the time, Kiesel was one of the best-known merchants in the west, owning the undoubtedly largest exclusive wholesale grocery house. He came to Utah at the age of 22, eventually making Ogden his permanent home. (Courtesy of WSU.)

Below is the David Peery residence on the corner of Adams Avenue and Twenty-fourth Street, named for Peery's home state of Virginia. This Victorian chateau was one of the most elaborate mansions in the Trolley District, with its substantial masonry form, round corner turrets, conical roofs, and classical detailing. The Peerys were excellent hosts, throwing many great parties at their home. One of the more famous was their initial housewarming, where hundreds of people came through the mansion in a fun and informal event complete with food, violins, pianos, and dancing. (Courtesy of Union Station.)

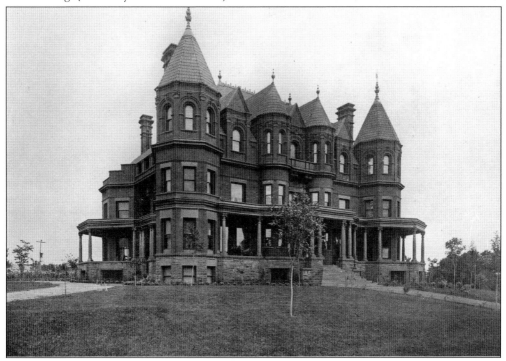

These photographs featuring children playing in the water epitomize the ideal, park-like setting the Eccles neighborhood was designed to foster. Here, the Morrell boys, the Larkin boys, the Healy boys, and the Eccles boys cool off on a hot Ogden day. The Healy Home is in the background, still standing at 2580 Eccles Avenue. (Both, courtesy of Thomas Moore III.)

The home of Edmund Orson Wattis Jr. and Martha Ann Bybee Wattis was designed by Eber Piers and built in 1914. E.O. started Wattis Brothers Construction with his brothers, William and Warren, but went out of business in the panic of 1893. In 1900, they tried again, founding the Utah Construction Company. Four years later, they were awarded the contract to build the Feather River route between Oakland and Salt Lake City, and the company thrived after completion of the project, soon capturing a large share of the tunneling, grading, and track projects for the rapidly expanding railroads in the mountains. They were one of the major contractors helping to build the Hoover Dam in Nevada.

The Wattis family poses on the front steps of their home in Eccles Circle. They are, from left to right, E.O. Wattis, Edmund Wattis Littlefield, Martha Bybee Wattis, Ruth Gwilliam, and Marguerite Littlefield in the rear. Marguerite was E.O. and Martha's daughter. Edmund Littlefield served in World War II and spent a great deal of time with his mother and grandparents in Eccles Circle. (Courtesy of WSU.)

Wilhelmina "Minnie" Kiesel Shearman, the only daughter of Ogden mayor Fred J. Kiesel and his wife, Julia, lived at 2532 Eccles Avenue. After the death of Martha Society founder Martha Brown Cannon, Julia Kiesel became president of the organization, which eventually transitioned into today's Junior League of Ogden. Well known in Salt Lake City and Ogden, Minnie Shearman, whose husband, W.H. (Harry) Shearman, was a Salt Lake City commissioner and on the water works board, entertained frequently. The Shearmans were often a worthy target of flattery in the society pages. (Courtesy of WSU.)

Minnie Shearman was one of the more social residents of the Eccles neighborhood. Her bridge parties often included a who's who of the Trolley District elite. Often, both guest lists and decorations appeared in local papers, with special attention paid to the colors of flowers, types of candle holders, and styles of napkin. She was married at the home of her father, Fred J. Kiesel, at Twenty-first Street and Adams Avenue. (Courtesy of WSU.)

Keitaru "Paradise" Kikuraku, Wilhelmina Kiesel Shearman's lifelong chauffeur and housekeeper, poses in the driver's seat. A Japanese American, Paradise was a unique presence in town. In one infamous story, Mrs. Shearman was entertaining the Weeks family for dinner and everyone was amazed at how fast he cleaned up, only to later discover that he had put all the dishes and cooking utensils in the oven to be cleaned the next day. (Courtesy of WSU.)

This rare view of the Wattis rose garden looks east, with the rear of the Marriner Eccles home beyond the fence. The children playing in the yard are Edmund Wattis Littlefield and Barbara Littlefield Kimball. The photograph was taken in June and an original caption describes a mass of pink blooms on the rose arbor. (Courtesy of WSU.)

This photograph was taken around 1920 near the walnut tree in the rear yard of the Weeks residence at 2529 Eccles Avenue. Looking to the north, the roofline of the Eccles home can be seen beyond the wall as the Weeks children play in the yard. Otis Weeks was the chief engineer of the Salt Lake division of Southern Pacific Railroad. Otis and his wife, Edith V. Weeks, were the second owners of the home, originally built by J.M. Canse. (Courtesy of WSU.)

Marriner S. Eccles, another son of prominent Ogden businessman David Eccles, attained his own national significance when he was appointed chairman of the Federal Reserve under Pres. Franklin Delano Roosevelt. In the midst of the Great Depression, Eccles was involved in the creation of the Emergency Banking Act of 1933 and the FDIC. He is seen here in his home at 2541 Van Buren Avenue in the Eccles subdivision. (Courtesy of WSU.)

Leslie S. Hodgson was a prominent Ogden architect from 1906 to 1947 and is responsible for many commercial, institutional, and residential buildings in and around the Trolley District. Originally from Salt Lake City, Hodgson studied under Frank Lloyd Wright before moving to Ogden in 1906, designing more than 75 buildings in 40 years, including Ogden High School, Ben Lomond Hotel, Peery's Egyptian Theater, and the US Forest Service building. He also laid out the David Eccles subdivision. (Courtesy of WSU.)

Heber Scowcroft (left), the son of John Scowcroft, was born in Lancashire, England, coming to America with his father in 1880 at age 12. By the time he was 17, he was heavily involved in his father's wholesale business. He married Ellen Pingree in 1890, but she passed away in 1900, leaving three children behind. Scowcroft then married her younger sister, Ida, with whom he had eight more children, who all lived in the family home (shown below), built in 1909. The mansion was designed by Moroni Charles Woods and is a superb example of foursquare Neoclassical design. The detailing in this photograph shows the porch and entrance on the west side, which are no longer there. The saplings are now towering sycamore trees. (Both, courtesy of WSU.)

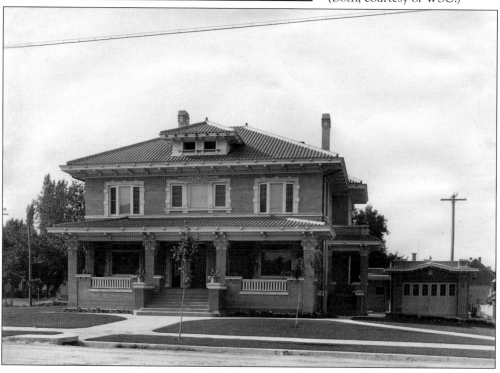

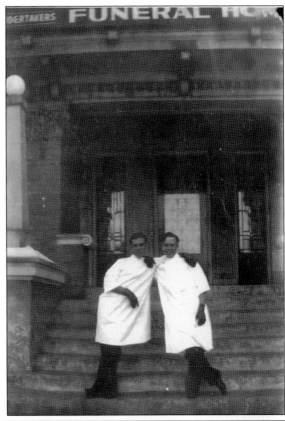

The Malan Mortuary Co. acquired the Heber Scowcroft home upon Scowcroft's death in 1925, and maintained its funeral home at the building during the early 1930s. According to title, the Malans operated the mortuary through approximately 1936. One cannot help but notice the enthusiasm the Malans showed for their occupation, evidenced by the smiles on their faces. These photographs were possibly taken in the late 1920s, as the outline of the First Church of Christ Scientist is visible across the street in the image below. (Both, courtesy of the Malan descendants.)

The Ralph Bristol House at 2480 Van Buren Avenue featured a wrought-iron porch roof said to have been a gift from a French political figure. It is also rumored that Leroy Eccles built his larger and more stately house at 1029 Twenty-fifth Street in response to this house. Although divided into eight apartments over time, the house still stands with the interior somewhat intact. The ballroom in the attic level is exemplary and the floor remains today. (Courtesy of WSU.)

The home of Dr. Edward Rich is pictured in the background of this photograph of kids posing on the fence around the home of Chris Flygore. Pictured are, from left to right, Chris Flygore, Alvin James, and Lillian Flygore. (Courtesy of Union Station.)

Six

THE TROLLEY DISTRICT TODAY

After the disbanding of the streetcar companies and paving over of the tracks, the Trolley District underwent a great transformation. Ogden's decline began as early as the 1940s, when new diesel technology eliminated the need for cross-country trains to stop in Ogden. At the same time, the war ended, delivering thousands of troops back to Ogden. In an effort to make way for an influx of population, many larger old homes were cut up into apartments, while thousands of post-war cottages were quickly thrown up at the periphery of the city. Many Ogden families left the urban center in favor of auto-centric suburbia. The city, facing a surplus of vacant buildings, turned toward questionable urban renewal methods including scrapping entire historic sites while converting others to public housing and social services facilities. Crime increased, housing options deteriorated, and Ogden was left with nothing but a racy Twenty-fifth Street and a central city that lacked definition.

Ogden continued to struggle for the next four decades, but thanks to historic preservation efforts, some major landmarks were saved from annihilation. The David and Bertha Eccles Mansion was transformed into a community art center in 1959. Ogden City residents mobilized to save Union Station from demolition in 1974. In 1997, the David Eccles building and the Egyptian Theater were saved and integrated into a modern hotel and convention center. The Junior League of Ogden undertook a massive historic inventory project in 1979–1980. In 1978, the David Eccles subdivision and Twenty-fifth street were placed under the jurisdiction of the local historic register. Jefferson Avenue was added to the register in June 2004.

In 2000, the youngest mayor in Utah history, Matthew Godfrey, took office in Ogden. While his 12-year tenure was not without controversy, he was determined to rejuvenate the central city. The local historic districts enjoyed public improvement efforts like uncovering the trolley tracks on Jefferson, and period lighting installed in both the Eccles and Jefferson districts. The city simultaneously worked to oversee the renovation of historic buildings, while encouraging home ownership through the city's Own in Ogden program.

By 2006, a grassroots movement to revitalize the Trolley District was in full swing. Neighborhood watch meetings turned into backyard potlucks because there was not much to "watch" for. Families moved back to the neighborhoods with children in tow, and houses were renovated. Ogden City's Home Sweet Ogden program has placed nearly 80 owner-occupant families in renovated houses within the district since 2005.

Today the city is considering the possibility of building a modern streetcar system. Across the country, streetcars are being re-discovered as great people-movers, economic drivers, and community builders in the tradition of the early streetcar systems. Perhaps someday soon, streetcars will once again roll along the streets of the Trolley District.

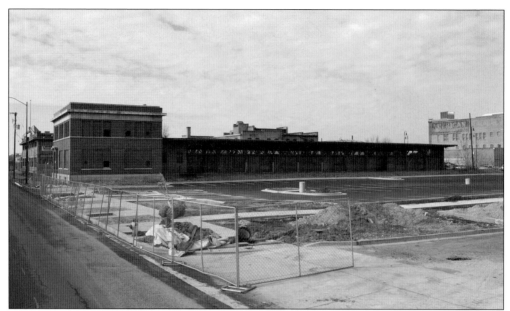

The Denver and Rio Grand (DRG) Building was purchased in 2010 by the Boyer Company with the intention of renovating the building for Internal Revenue Service (IRS) office space. The IRS currently occupies a large portion of the block, including the renovated Scowcroft Warehouse on the far right. Unfortunately, the plans for the DRG have not come to fruition, and the building is under threat of demolition. (Photograph by Shalae Larsen.)

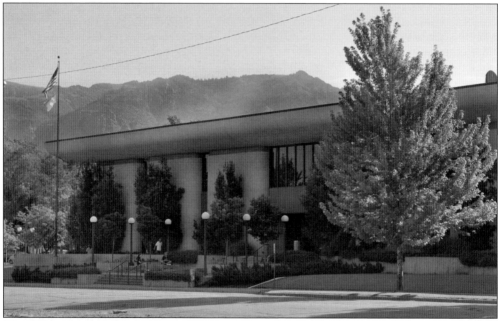

The Weber County Library was completed in 1968 on the 2400 block of Jefferson Avenue. Designed by Utah architect John L. Piers, the modernist structure is reminiscent of Chapel Ronchamp by the renowned architect Le Corbusier. Built at a cost of $1.75 million, the interior features furnishings by Charles and Ray Eames. The structure is truly magnificent and is a cherished landmark in the Trolley District's architectural timeline. (Photograph by Shalae Larsen.)

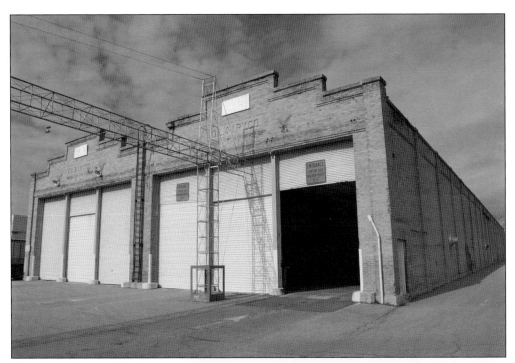

The magnificent trolley barns, originally built by the Ogden, Logan & Idaho Railway, are now owned by the state. The "O.L. & I. Ry." was the result of the merging railroad and street rail companies in 1915. After finalizing the routes to points beyond, the railway company transitioned to the Utah Idaho Central. Instead of streetcars and steam engines, the buildings now house a state grain-grading facility. The buildings, on Seventeenth Street just east of Wall Avenue, still retain their immense brick walls, skylights, and monikers on the front. The Ogden Bishops' Storehouse also uses the adjacent trolley barns for their warehouses. The barns on Seventeenth Street appear to be the only trolley barns remaining in Ogden. (Photographs by Shalae Larsen.)

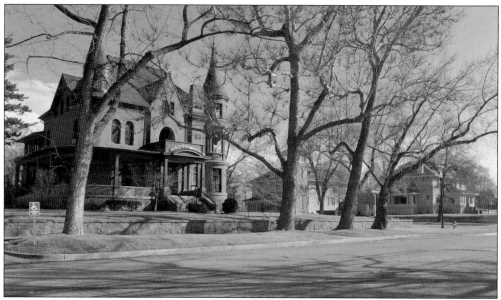

This modern-day view of the Jefferson Avenue district looks southeast towards the Eccles Community Art Center. The streetcar tracks were uncovered in 2003 and today almost 92 percent of the historic district is now owner-occupied single-family housing. The rebirth of the Jefferson district and its sense of community have inspired the fondly named "Jefferson Supper Club," a group of neighbors who regularly meet for dinners and social events. (Photograph by Shalae Larsen.)

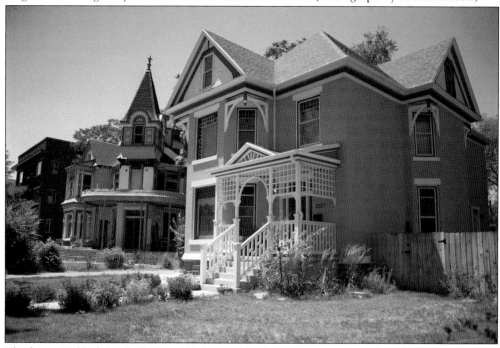

The former Helfrich-Healy (left) and Hulaniski (right) residences stand side-by-side, both undergoing restorations. The Helfrich-Healy residence is being restored by Alan and Cindy Toone, while P.J. and Lydia Gravis are enjoying life in the newly renovated Hulaniski home. (Photograph by Jessica Hollon.)

Thomas Carr had his pharmacy on Twenty-fifth Street and built his brick Arts & Crafts home on Jefferson Avenue in 1909. The home transitioned into a title company, complete with fluorescent lighting in every room. The historic kitchen was removed and the home continued its decline until it was purchased in 2006 by Chip and Tamara Anderson, who have lovingly restored it to its former glory. (Photograph by Tamara Anderson.)

In January 2004, Ogden City Neighborhood Development tore down the house at 2563 Jefferson Avenue due to a loss of structural integrity. Co-author Sue Wilkerson designed and built the replacement Arts & Crafts infill home, and entered it in the Parade of Homes. In the last several years, the area has experienced a resurgence; today, nearly all of the homes in the two-block area are owner-occupied and restored. (Photograph by Shalae Larsen.)

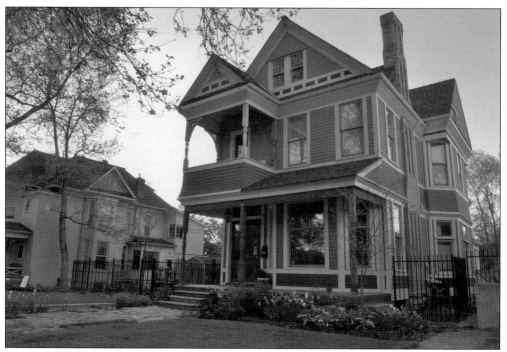

In 2002, co-author Shalae Larsen and her husband, Travis, purchased the historic John W. McNutt home on Twenty-fourth Street. Shortly after beginning the renovation, the house caught fire and was nearly destroyed, but the owners worked for over four years to rebuild the home, which today features original exterior woodwork, wood windows, straight-grain Douglas fir flooring, and an oak balustrade. (Photograph by Shalae Larsen.)

Amazingly, this home at 1062 Twenty-fourth Street is still intact today, although the porch has been altered. The surrounding neighborhood has filled in significantly since it was built in the 1880s. Note the century-old sycamore trees, the canopy of which lines much of Twenty-fourth Street. (Photograph by Shalae Larsen.)

These two Dutch colonials were originally built between 1904 and 1910 and are prime examples of the transition that occurred in Ogden's Trolley District neighborhoods. They were both divided into multifamily residences and converted back to single-family homes in 2005–2006. The restoration, performed by Ogden City Neighborhood Development, was historically sensitive, preserving the features that make the homes unique. (Photograph by Shalae Larsen.)

This streetscape along Twenty-fifth Street just west of Monroe Boulevard illustrates the diversity of houses in the Trolley District. Many historic homes in Ogden became group homes or public office buildings of some type. Some of the homes have been placed on the local historic register, further assisting their survival into the 21st century. The Warner and Parmley homes seen in chapter three are at the far right. (Photograph by Shalae Larsen.)

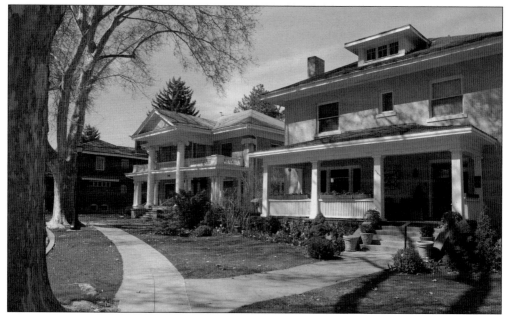

Today, century-old sycamore trees grace the Eccles Historic District, as seen in this photograph featuring the Canse-Weeks and Wright-Morrell homes. In fact, the trees have grown so large that the trunks were engulfing the original sidewalk and curb. In an effort to preserve these landscape icons, the sidewalks and curb were shifted to accommodate root growth. (Photograph by Shalae Larsen.)

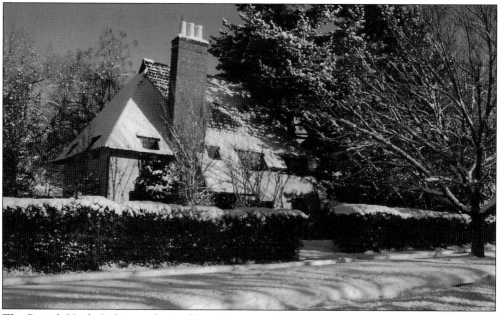

The Patrick Healy Jr. house changed hands again in 2011. The home has transitioned through many owners, including use as a real estate office building. Thanks to the Junior League of Ogden aligning with the neighbors in 1976, the area was saved from becoming a row of office buildings. Today, it is one of the more coveted streets in Ogden, with residents restoring their homes and enjoying the tranquil Watermelon Park. (Photograph by Thomas Moore III.)

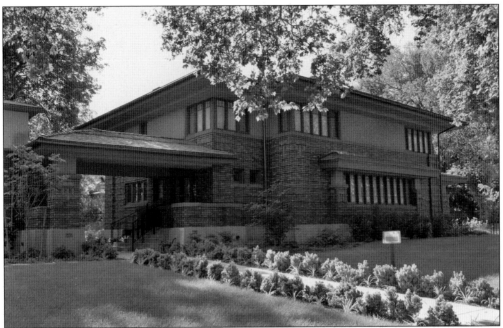

In 2004, after four decades of neglect, the E.O. Wattis House was bought back by the descendants of the original owner. Fortunately, much of the home's original character was left intact, including the woodwork and stained glass windows. Edmund Littlefield, Denise Sobel, Paul Wattis Jr., and Paul Wattis III worked with CRSA Architects to realize a complete restoration of the home. Author Shalae Larsen was the landscape architect on the project, designing a Prairie style landscape to complement the architectural character of the home and preserve one of its original stone fountains (below). Today, the home once again stands as the climax of the Eccles Avenue Historic District. (Photographs by Shalae Larsen.)

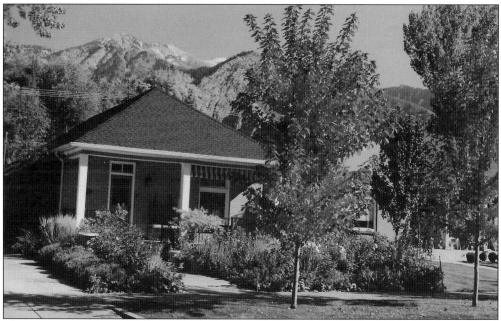

This quaint 1902 farmhouse has passed through many owners. It foreclosed twice in the early 2000s and had gone downhill, with old carpet, a shabby kitchen, and evidence of deterioration throughout. In 2005, it was purchased by Thomas & Stephanie Moore, who restored it to the present-day historic gem that it is. Graced by impeccable landscaping, the property is a treasure in the Eccles Historic District. (Photograph by Thomas Moore III.)

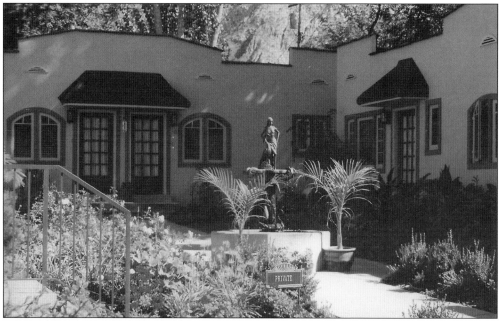

Patterned after a similar property built in Pasadena, California, the Villas are built in the Spanish Revival style. Originally designed to house newlywed couples who were starting their lives together, the Villas went into a downward spiral for decades. Purchased by the Moore family in 2006, the Villas were restored to showplace condition. (Photograph by Thomas Moore III.)

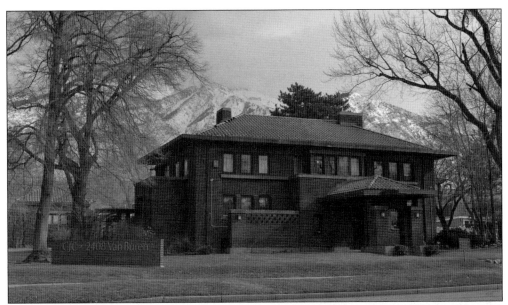

The Becker Mansion is now the home of the Children's Justice Center. In the 1980s, many of the largest mansions in the district became home to state agencies, attorney's offices, or multifamily homes. The property features a beautiful Prairie-style pergola connecting the mansion and carriage house that until a few years ago was covered with wisteria. (Photograph by Shalae Larsen.)

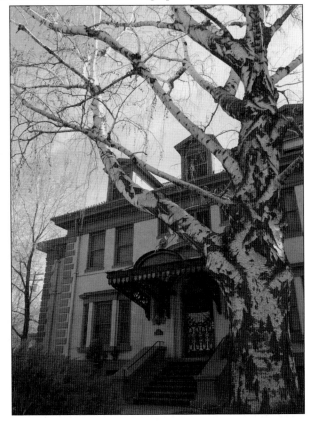

The formerly glorious Ralph Bristol Mansion has been converted to eight apartments, with a large garage added on the south side. Although the apartment conversion is choppy, many of the historic features still exist. The ballroom floor in the attic is still apparent, albeit in two different apartments. The original canopy, a gift from a French dignitary, is still intact. (Photograph by Shalae Larsen.)

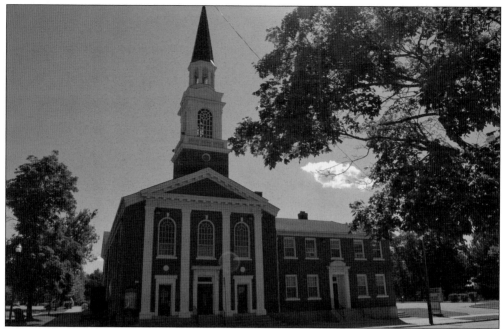

First organized in 1881 by Rev. Dwight Spencer, this church was initially at Twenty-fourth Street and Grant Avenue. In 1920, this land was sold to the church and Slack Winburn and Walter Ware designed the structure, which was completed in 1925. The west wing was added, surrounding an outdoor courtyard with the gymnasium wing built off the south side. Still under the same ownership, this charming, historic building graces the Jefferson Historic District today. (Photograph by Shalae Larsen.)

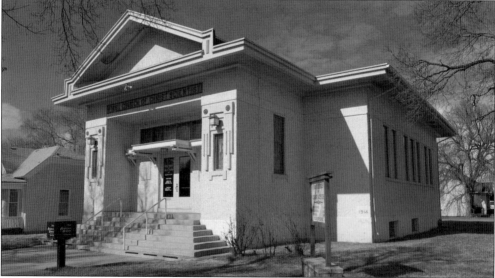

One of the best-preserved works of Eber Piers rests in the hands of the Church of Christ Scientist. Originally built in 1914, the interior of the building is breathtaking. Natural untouched gumwood surrounds the lavender-tinted stained glass and the pews are built for the original slightly sloping sanctuary floor. The basement was dug out and added for modern conveniences in the 1950s and 1960s. (Photograph by Sue Wilkerson.)

The US Forest Service Region No. 4 headquarters is now a landmark in the Trolley District. Designed by the architectural firm of Hodgson & McClenahan, the 1933 building shares its Art Deco style with the Ogden City Municipal Building and Ogden High School. One of the most fascinating architectural features is the greenhouse on the roof, with its original glass still intact. (Photograph by Shalae Larsen.)

Beginning in 2006, the Ogden School District and the Ogden High School Foundation kicked off a $70 million project to restore Ogden High School and create a fully functional modern high school facility. In addition to the complete restoration of the Art Deco auditorium, a modern cafeteria addition designed by EDA Architects and built by Hughes Construction complements the historic architectural style. (Photograph by Hughes Construction.)

ABOUT THE AUTHORS

Authors Shalae Larsen and Sue Wilkerson are both passionate advocates for Ogden. While they were originally opponents on some highly controversial local political issues, they soon found common ground in the revitalization of the Trolley District.

Shalae Larsen and her husband, Travis, discovered Ogden in 2002 when Shalae was finishing her bachelor's degree in landscape architecture at Utah State University in Logan. While making plans to relocate post-graduation to the Salt Lake area, they discovered an amazing Victorian home in Ogden. As avid outdoor enthusiasts who also love old buildings, Ogden offered an ideal combination of skiing, biking, hiking, and history.

Professionally, Larsen is the principal landscape architect for IO Design Collaborative, working on the preservation of historic landscapes and the creation of new sustainable and socially responsible projects. She also has a master's degree in architecture and a historic preservation certificate from the University of Utah and is working toward licensure in architecture.

Sue Wilkerson believes in Ogden, probably more than most. Watching the city change over the past 11 years has been inspiring to her and has provided her with the experiences she shares on a blog dedicated to her love of Ogden.

Wilkerson's dedication to community started at an early age, growing up in Boulder Creek, California. Her spirit of civic responsibility was fueled by a college internship with Congressman Leon Panetta in Washington, DC. After graduating from Cal Poly, San Luis Obispo in agriculture, Wilkerson went on to build an agricultural trucking business with her then-husband Ralph in Woodland, California. Moving to Utah in 1997, she spent some time in air freight before settling into real estate in 1999. Sue launched her brokerage, Terra Venture Real Estate, in 2002. After 10 years as an independent broker, Sue purchased a RE/MAX franchise, opening as RE/MAX Crossroads in the newly remodeled Heber Scowcroft mansion in June 2012. Real estate led her to fall in love with Ogden and its historic districts with grand mansions of yesteryear.

BIBLIOGRAPHY

Bennett, Gilbert H. and Stephen L. Carr. *Railway Reflections: A Historical Review of Utah Railroads.* Ogden, UT: Ogden Union Station Foundation, 1999.

Carter, Thomas and Peter L. Goss. *Utah's Historic Architecture, 1847–1940: A Guide. Salt Lake City.* Center for Architectural Studies, Graduate School of Architecture, University of Utah, and Utah State Historical Society, 1991.

Crawford, D. Boyd. *History of Ogden: Utah in Old Postcards.* Ogden, UT: Maury Grimm, 1996.

A History of Ogden. Pre-print of the Proposed Inventory of Municipal Archives of Utah. Ogden, UT: Ogden City Commission, 1940.

Hunter, Milton R. *Beneath Ben Lomond's Peak: A History of Weber County, 1824–1900.* Salt Lake City: Quality, 1995.

Jenson, Andrew. *Latter-Day Saint Biographical Encyclopedia: A Compilation of Biographical Sketches of Prominent Men and Women in the Church of Jesus Christ of Latter-Day Saints.* Salt Lake City: A. Jenson History, 1901.

Olsen, Jalynn. *Building by the Railyard: The Historic Commercial and Industrial Architecture of Ogden, Utah.* Salt Lake City: Graduate School of Architecture, University of Utah, 1998.

Sillito, John R. and Sarah Langsdon. Images of America: *Ogden.* Charleston, SC: Arcadia Publishing, 2008.

Strack, Don. *Ogden Rails: A History of Railroading at the Crossroads of the West.* Cheyenne, WY: Union Pacific Historical Society, 2005.

Tillotson, Elizabeth M. *A History of Ogden.* Ogden, UT: J.O. Woody, 1962.

Warrum, Noble, Charles W. Morse, and W. Brown Ewing. *Utah Since Statehood: Historical and Biographical.* Chicago and Salt Lake City: S.J. Clarke Publishing, 1919.

Woodhouse, Irene. *Ogden Anecdotes: Stories and Photographs from Our First Fifty Years.* Ogden, UT: Woodhouse, 2004

Discover Thousands of Local History Books Featuring Millions of Vintage Images

Arcadia Publishing, the leading local history publisher in the United States, is committed to making history accessible and meaningful through publishing books that celebrate and preserve the heritage of America's people and places.

Find more books like this at
www.arcadiapublishing.com

Search for your hometown history, your old stomping grounds, and even your favorite sports team.

Consistent with our mission to preserve history on a local level, this book was printed in South Carolina on American-made paper and manufactured entirely in the United States. Products carrying the accredited Forest Stewardship Council (FSC) label are printed on 100 percent FSC-certified paper.

MADE IN THE USA